D0976649

HYDROPLANE
RACING
IN SEATTLE

RECEIVED

OCT ⁻ 2006

BALLARD LIBRARY

NO LONGER PROPERTY OF
SEATTLE PUBLIC LIBRARY

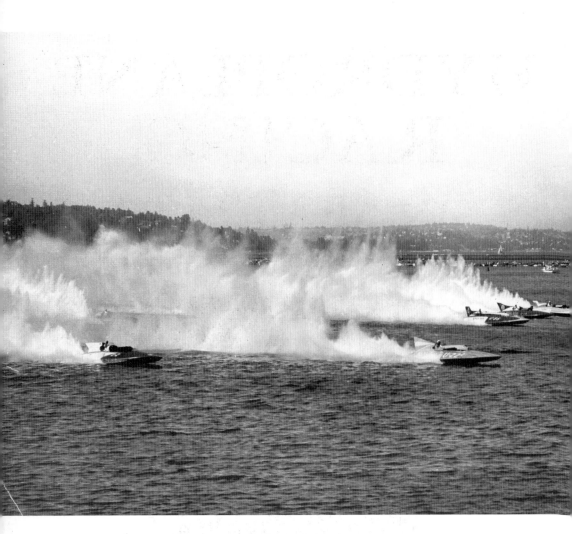

JAY MURPHY AND THE *BREATHLESS TOO* lead the start of heat 2-A at the 1958 Gold Cup. Pictured, from left to right, are Fred Alter in the *Miss U.S.*, Murphy and the *Breathless Too*, Al Benson in the *Pay N' Save*, Roy Duby in the *Gale VI*, Harry Reeves in the *Coral Reef*, and Bill Muncey in the *Miss Thriftway*. Seconds after this photograph was taken, the *Miss Thriftway* lost its rudder and crashed into a U.S. Coast Guard boat. (For more photographs of this incident, please see chapter 3.) (Photograph by Bob Carver.)

FRONT COVER: The restored *Slo-mo-shun V*, driven by author David Williams, streaks underneath the I-90 bridge in 2001 during the Hydroplane Museum's reenactment of the first flying start. (Photograph by E. K. Muller.)

BACK COVER: The 1958 *Miss Bardahl*, designed by Ted Jones and built by his son Ron Jones, won its very first race and was the 1958 national champion.

HYDROPLANE
RACING
IN SEATTLE

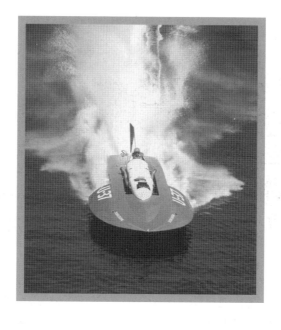

David D. Williams

ARCADIA
PUBLISHING

Copyright © 2006 by David D. Williams
ISBN 0-7385-3118-9

Published by Arcadia Publishing
Charleston SC, Chicago IL, Portsmouth NH, San Francisco CA

Printed in the United States of America

Library of Congress Catalog Card Number: 2006920547

For all general information contact Arcadia Publishing at:
Telephone 843-853-2070
Fax 843-853-0044
E-mail sales@arcadiapublishing.com
For customer service and orders:
Toll-Free 1-888-313-2665

Visit us on the Internet at www.arcadiapublishing.com

CONTENTS

ACKNOWLEDGMENTS

One of the things that I find so appealing about hydroplane racing is that everything about it seems to ignite tremendous passion. Fans of a specific team or driver support "their" boat with undying loyalty. Students of its history will debate the finer points of racing lore, as if world peace hung in the balance. Collectors of buttons or uniforms will mortgage their home to buy a treasured piece of memorabilia. The supporters and volunteers of the Hydroplane and Raceboat Museum have tapped into this same enthusiasm to create a wonderful shrine to the history of the sport. From the beautifully restored boats to the hand-built models in intriguing display cases, everything at the museum combines to tell the breathtaking story of the Americas' oldest and most exciting motor sport. It is with sincere respect and admiration for every volunteer and donor that I proudly dedicate this book to the hardest working people I know—the amazing volunteers of the Hydroplane and Raceboat Museum.

—David D. Williams

Visit the Hydroplane and Raceboat Museum at:
5917 South 196th Street
Kent, Washington 98032
Or log on to www.thunderboats.org

This book was produced using the extraordinary photograph collection of the Hydroplane and Raceboat Museum. Over the last 20 years, tens of thousand of photographs have been donated to the museum. Some were clearly marked by the original photographer; many were not. In preparing this book, I have attempted to identify and give proper credit to every photographer whose work was used. However, in some cases I was simply unable to identify the photographer. I am continuing to research the origin of any unidentified photograph, and where possible, the photographer will be credited in future editions of this work.

INTRODUCTION

Why write a book about hydroplane racing? And what possible relevance do hydros have today, while Seattle seems deeply rooted in mainstream stick and ball sports?

As I write this, the Seahawks are headed to Detroit for their first ever Superbowl appearance. The fanaticism that motivates normally tranquil Seattleites to paint their faces green and blue seems to be a long way removed from the halcyon days of boat racing, but in fact, they are closely linked in several ways.

First, the deep rooted civic pride that fires the antics of Seahawk, Mariner, or Sonic devotees was born and bred in the early 1950s, when Seattle sports fans first found their collective voice cheering for the hometown Slo-mo-shuns. Second, the feverish support that Seattle is currently showing for the Seahawks is identical in nature to the support that locals once gave to the hydros. In fact, the *Times* and *PI* both used to refer to the summer madness that took over the city as "Hydro Fever." Finally, if it were not for the hydros, there would not be any Seahawks, Sonics, or Mariners today.

There is a direct and demonstrable link from the hydros to Seattle's modern professional teams. The civic powers that coalesced to put the races on between 1951 and 1959 became so adept at hosting large civic events that they decided to bid on the 1962 World's Fair. Of course, that bid was successful and Seattle now has the Space Needle, Key Arena, and the monorail as regional icons because of it. In the closing days of the World's Fair, Seattle mayor Gordon Clinton called for the fair promoters (actually just cleaned up boat race promoters) to turn their attention to bringing professional sports to town, and with help from the Olympia, city hall, and the county council, they did just that.

It is possible to argue that no single sporting event has ever impacted a major metropolitan area as much as hydro racing affected Seattle. Here then is the remarkable story of hydroplane racing in Seattle!

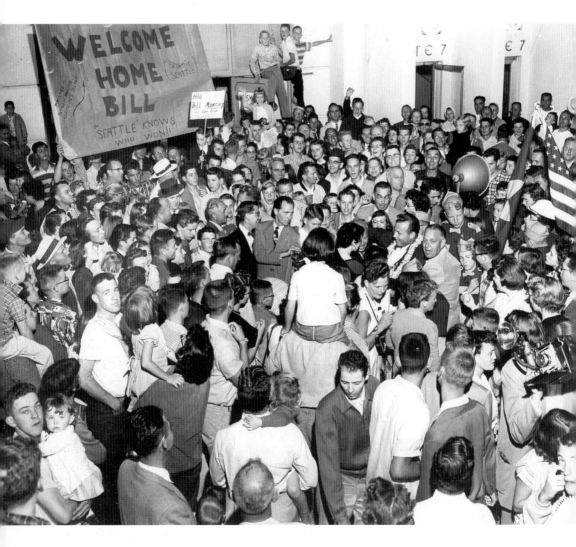

BILL MUNCEY IS SWARMED BY cheering fans when he returns to Seattle after the much disputed 1956 Gold Cup. Note the banner in the upper left that says, "Seattle Knows Who Won!" (Courtesy Northwest Airlines.)

1

1909—1948
THE BEGINNING

Any way that you look at it, 1909 was an important year for powerboat racing in Seattle. The Alaska Yukon and Pacific Exposition (AYPE) opened in June of that year to commemorate the Yukon gold rush. In the first week of July, the AYPE featured motorboat races. The premier event was the Pacific Coast Championship (PCC). This was the first "big league" race in Seattle's history.

The PCC consisted of three heats spread out over a week from July 3 to July 10. Two entries were shipped from Portland by train—the *Wolf II*, owned by John Wolf and E. W. Spencer, and the *Pacer*, owned by R. O. Cox. Seattle was represented by the *Spirit of Seattle*, belonging to Ralph Casey and Charles Binkley. The race was three laps around a 10-mile course. It started near the current location of Husky Stadium, along Lake Washington to Leshi, then across the lake to Medina, and back to the AYPE dock. The *Wolf II* easily won all three heats and claimed the honor of winning the first major powerboat race on Lake Washington.

In October of the same year, Tudor Owen (Ted) Jones was born. Ted would play an important role in making Seattle the hydroplane capital of the world.

The AYPE was a huge success and led to an annual celebration called the Golden Potlatch. The first Potlatch was held in 1911 and included many of the same elements that would make Seafair such a big hit 40 years later, including boat races. The *Swan*, owned and driven by Tony Jensen, won the race that year. Tony later founded Jensen Motorboat Works, and his son Anchor would play a central role in Seattle's love affair with hydroplanes.

The Potlatch grew in popularity until 1913, when members of the International Workers of the World (WOBBLIES) got into a fight with sailors from the fleet. The scuffle turned into a riot that did not end until Seattle mayor George Cotterill took personal control of the police force. The festival struggled through one more year, but attendance was down in 1914 and the festival did not come back in 1915.

On August 10, 1938, a group of inboard racers formed the Northwest Inboard Racing Association (NIRA). L. W. Van Dyke was the commodore and Ted Jones was the regatta chairman. In 1941, Ted was elected commodore. However, World War II brought the sport to a halt, and the club lay dormant until the end of the war. Ted continued as commodore through 1946.

The folks at NIRA were not the only Seattleites interested in fast boats. Stanley Sayres, a successful Chrysler dealer in Seattle, also had a passion for fast boats. In 1937, he bought a record-setting Ventnor 225 named *Tops* from Jack "Pop" Cooper of Kansas City. Stan renamed the boat *Slo-mo-shun*. In 1941, the boat caught fire and was destroyed. In 1942, Stan bought the *Tops III* from Cooper, renaming it *Slo-mo-shun II*. The boat was damaged while being shipped

from Kansas City.

Stan's business partner, Harry Jensen, suggested that Stan take the boat to his brother Tony's boatyard for repairs. Tony's talented son Anchor was well known for his superb craftsmanship. Anchor looked at the job, but he was too busy to take on new work. He recommended that Stan hire Ted Jones to make the repairs.

Ted was a supervisor at Boeing but had established a formidable reputation in the racing community by building his own fast 225 named *Phantom*, as well as a boat named *Wasp* for Glenn Van Dyke and a recorded-setting 135 named *Avenger* for Eddie Meyer of California.

Ted took on the job of rebuilding the sponsons, and Stan was happy with the results. The two racers kept in touch during the war years, and in 1947, Stan approached Ted about building a new boat. Ted offered to build a Gold Cup–class boat, but Sayres, prudently suggested they start with a 225 to be called *Slo-mo-shun III*.

When the *Slo-mo-shun II* had belonged to Pop Cooper, it had set the world record for 225's at 87.48 miles per hour. Stan and Ted's goal for the new *Slo-mo-shun III* would be to reach 90 miles per hour. Ted's design was basically a larger version of the *Avenger*. Ted began the construction in the basement of his home but was unable to complete the boat in the timeframe Sayres requested, so the boat was moved to Jensen's and completed with Anchor's help.

The *Slo-mo-shun III* never raced but apparently met the goal of hitting the 90-miles-per-hour mark. According to Anchor, "No sooner had he (Stan) gotten use to the 90 mile an hour speed of the 225 *Slo-mo-shun III* than he was plagued with the urge to go faster."

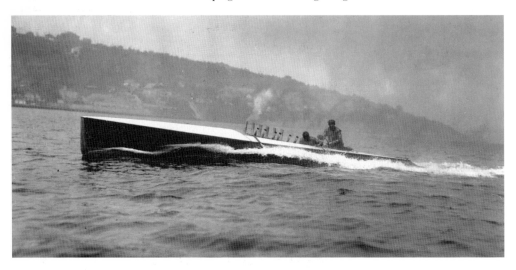

THE BRIGHT RED *SPIRIT OF SEATTLE*, owned by Ralph Casey and Charles Binkley of the Seattle Yacht Club, represented Seattle in the Alaska Yukon Pacific Exposition Regatta. Construction of the *Spirit of Seattle* was completed shortly before the race and "the new boat blues" kept it from finishing all but one heat. During the regatta, it reached a top speed of 32.4 miles per hour before breaking down. By the following year, all of the bugs had been worked out and the *Spirit* won the Pacific Coast Championship, earning it the title of "Fastest Boat on the Pacific Coast." (Courtesy Puget Sound Maritime Historical Society.)

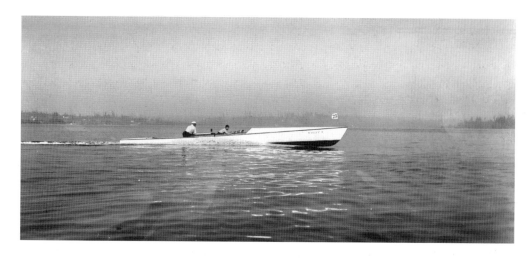

PORTLAND, OREGON'S, *WOLFF II* was owned by John Wolff and E. W. Spencer and is pictured here on the way to victory in the 1909 AYPE Regatta on Lake Washington. The *Wolff II* was 39 feet, 9 inches long, with a beam of four feet, five inches and a draft of only eight inches. In this photograph, the boat is steered by E. W. Spencer, a big man who weighed in at 265 pounds. A few months after this race, in an effort to save weight, the helmsman responsibility was turned over to 15-year-old Orth Mathiot. Mathiot won a number of Pacific Coast Championships in the Wolff boats and later with the *Vogler Boy*. Mathiot was killed in 1951 when his step hydroplane, *Quicksilver*, crashed in the final heat of the 1951 Gold Cup. (Courtesy Puget Sound Maritime Historical Society.)

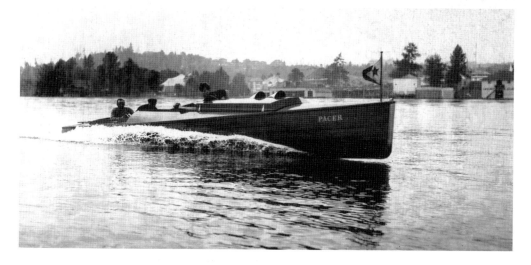

THE *PACER* WAS BUILT IN NEW YORK for Louis Roesch, who sold the boat to R. O. Cox of Portland. The *Pacer* was 32 feet long, with a five-foot, six-inch beam and a nine-inch draft. It finished second in the AYPE Regatta open class. (Courtesy Puget Sound Maritime Historical Society.)

Pacific Northwest

SPEED BOAT

CHAMPIONSHIPS

8 RACE BOATS 8

The Fastest Boats
west of the Mississippi River will compete

Fleet of Aeroplanes will give Daring Exhibitions
Worlds Champion Surf Board Rider will Compete
THE LAST CHANCE to see the Most Thrilling event of the Year

COLUMBIA BEACH AUG 8
SATURDAY, 2 P.M.

Take Columbia Beach street car :: Unlimited parking space for automobiles

Admission 50 cents *Children 25 cents*

Sanction of Portland Motor Boat Club

Tickets on sale at Rich's Cigar Stores - - Sixth and Washington and Broadway and Stark

AFTER THE GOLDEN POTLATCH FOLDED, big league, inboard powerboat racing in the Pacific Northwest was centered in Portland, Oregon. This poster advertises a 1922 race.

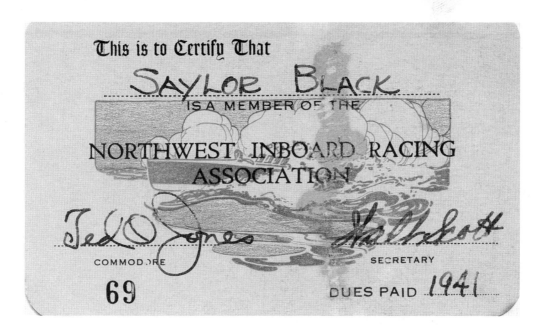

The Northwest Inboard Racing Association was formed in 1938 to conduct inboard races in Western Washington. Ted Jones held the position of commodore from 1941 to 1946. This membership card, issued in 1941, bears Ted's signature.

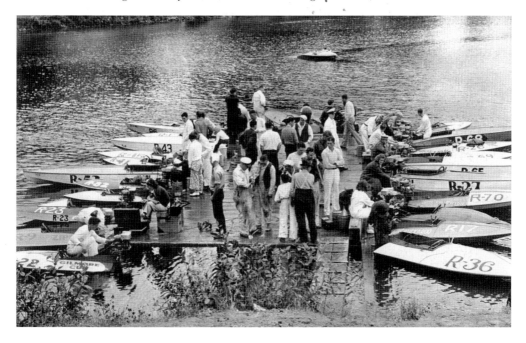

This is a typical early outboard race in the Pacific Northwest. Note that many of the participants in this photograph are women.

Women have always taken a large role in outboard racing.

HERE TED JONES SITS IN THE COCKPIT of his early three-point, 225 hydro, *Fireball, c.* 1940.

IN 1945, TED JONES BUILT the 135 hydro *Avenger* for Eddie Meyer of California. Eddie and his younger brother Louis were important figures at the Indianapolis 500. In fact, Louis won the race in 1928, 1933, and 1936. In 1946, Louis Meyer bought out Fred Offenhauser's motor-building business and with longtime friend Dale Drake, helped turn the Offenhauser engine in to the dominant motor for open-wheel car racing in America.

THIS IS AN EXTREMELY RARE PHOTOGRAPH of Ted Jones's 225 *Phantom*, built in the mid-1930s. (Courtesy John Leach.)

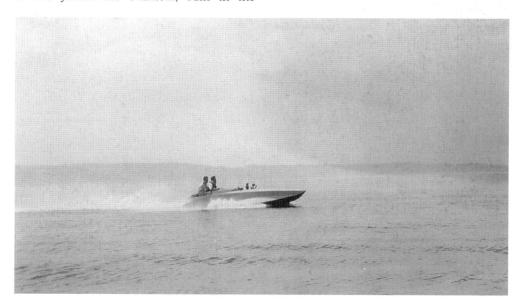

THE *PHANTOM* WAS A SUCCESSFUL boat that continued to race in the Northwest, with a number of different names and owners until the early 1950s. (Courtesy of John Leach.)

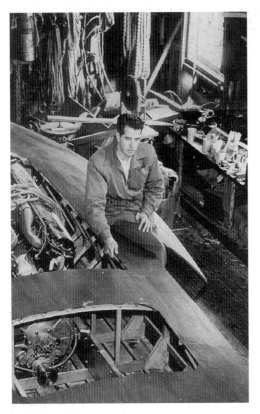

In 1909, Ted Jones, a self-taught, seat-of-the pants boat racer, was born in Seattle. He went to work for Boeing in the 1930s and became a supervisor on the Boeing 314. His experience working on the big flying boat taught him much about lightweight construction and high-speed planing surfaces. By 1948, he had built or designed more then a dozen 135 and 225 hydros including the *Wasp, Phantom, Fireball, Avenger, Miss Take, Idling Jett, Wildfire, and White Hawk.* (Courtesy Mary Randlett.)

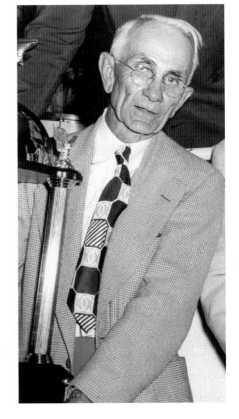

Pop Cooper, a successful 225 racer from Ohio, fielded a series of record-setting Ventnor boats named *Tops.* Seattle auto dealer Stan Sayres bought the first *Tops* from Pop in 1937 and renamed it *Slo-mo-shun.* In 1942, Stan bought the *Tops III* and renamed it *Slo-mo-shun II.*

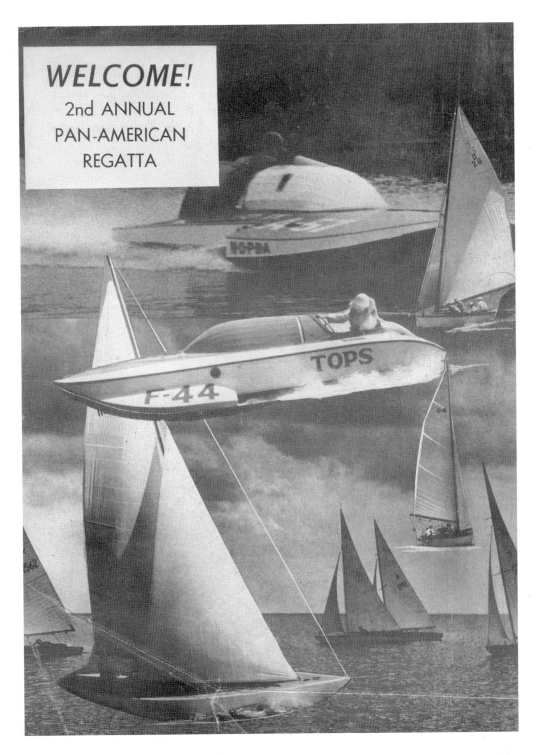

WELCOME!
2nd ANNUAL
PAN-AMERICAN
REGATTA

THIS PROGRAM COVER FROM the 1947 Pan-American Regatta features a photograph of the *Tops*, which became Stan Sayres's first *Slo-mo-shun*.

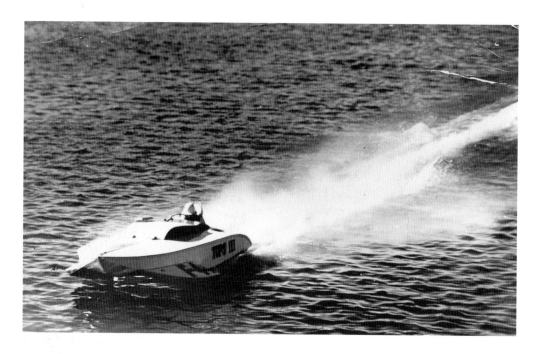

THE *TOPS III* WAS A WORLD RECORD-SETTING 225, which Pops sold to Stan Sayres in 1942; it became the *Slo-mo-shun II*. This boat was damaged while being shipped from Kansas City to Seattle, and Stan hired Ted Jones to do the repairs.

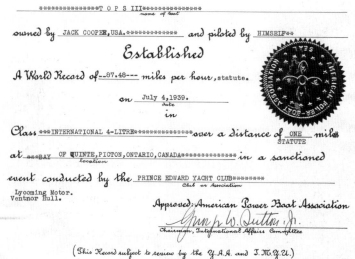

****ONE-MILE WORLD RECORD****

The American Power Boat Association

Certifies that

_____***************T O P S III***************_____
name of boat

owned by JACK COOPER,USA.************ *and piloted by* HIMSELF**

Established

A World Record of --87.48--- *miles per hour,*statute.

on July 4,1939.
date
in

Class ***INTERNATIONAL 4-LITRE***************over a distance of* ONE *miles*
STATUTE
at ***BAY OF QUINTE,PICTON,ONTARIO,CANADA************* *in a sanctioned*
location

event conducted by the PRINCE EDWARD YACHT CLUB********
Club or Association

Lycoming Motor.
Ventnor Hull.

Approved:American Power Boat Association

George W. Sutton, Jr.
Chairman, International Affairs Committee

(*This Record subject to review by the Y.A.A. and I.M.Y.U.*)

IN 1939, THE *TOPS III* SET A world speed record of 87.48 miles per hour. When Ted Jones offered to design an unlimited boat for Sayres, Stan replied that first he should build a 225 that could beat this record.

STANLEY ST. CLAIRE SAYRES was born in Dayton, Washington, in 1896. He graduated from Whitman College in Walla Walla in 1917 and entered the military. When he left the service at the end of World War I, he opened a car dealership near Walla Walla. By 1920, he had opened a second dealership in Pendleton, Oregon. By 1924, Stan added three more associated dealerships to his growing business. In 1931, he moved to Seattle to open up a Chrysler dealership and parts distribution center. Shortly after arriving in Seattle, he became friends with Harry Jensen. Stan and Harry became partners in a new business named Jen-Cel-Lite, which harvested cellulose from the waste wood products of local lumber mills and turned it in to insulation for sleeping bags. Large military contracts for sleeping bags made Jen-Cel-Lite a great success and deepened the bond between Stan and Harry. When Harry learned that Stan was interested in fast boats, he introduced Stan to his brother Tony Jensen, who owned Jensen Motor Boat Company on Lake Union. (Courtesy Jensen Motor Boats Archives.)

BORN IN 1918, ANCHOR JENSEN was raised into the world of boat building. His father, Tony, owned and operated the Jensen Motor Boat Company. Tony Jensen won the 1911 Golden Potlatch race in the *Swan* and built wooden powerboats and sailboats for many members of Seattle's upper class. Anchor attended the Washington School of Engineering in Seattle and the U.S. Naval Basic Engineering School at Great Lakes, Illinois. He had a tremendous reputation for being a meticulous craftsman, with an eye for innovative solutions to engineering problems. (Courtesy Ken Oller.)

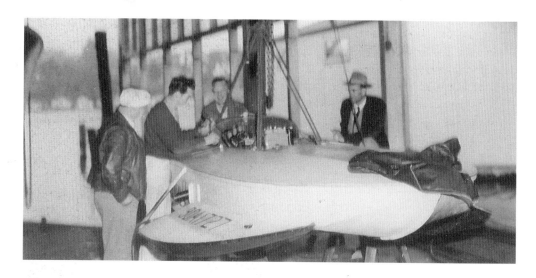

THIS SLIGHTLY BLURRED PHOTOGRAPH shows a very early meeting between Jones and Sayres. Stan Sayres is sitting in the cockpit of the *Slo-mo-shun II*; Ted Jones is on the left working on the motor. The man on the right may be Harry Jensen, and the man on the far left in the white hat is unidentified. (Courtesy Jensen Motor Boats Archives.)

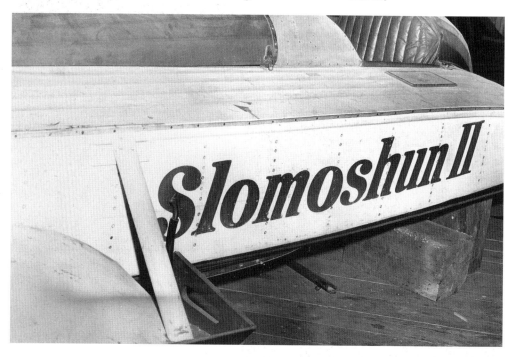

THE LEFT SPONSON OF THE *SLO-MO-SHUN II* was damaged in transport, and Stan asked Ted to do the repairs. This close up of the *Slo-mo-shun II*'s left sponson shows an extra frame that has been added to lengthen the running surface, making it more likely to prop ride. (Courtesy Jensen Motor Boats Archives.)

1909–1948: THE BEGINNING

THE *SLO-MO-SHUN II* IS IN THE WATER at Jensen's in the early 1940s. The boat's Coast Guard registration numbers are clearly visible and end with the number "27." Some people think that when Stan registered the *Slo-mo-shun III* and *IV* with the APBA, he requested the designations F-27 and U-27 because of this. (Courtesy Jensen Motor Boats Archives.)

HERE IS ANOTHER ANGLE OF THE *Slo-mo-shun II* at Jensen's. Note that the modification extending the sponsons has not been made yet. (Courtesy Jensen Motor Boats Archives.)

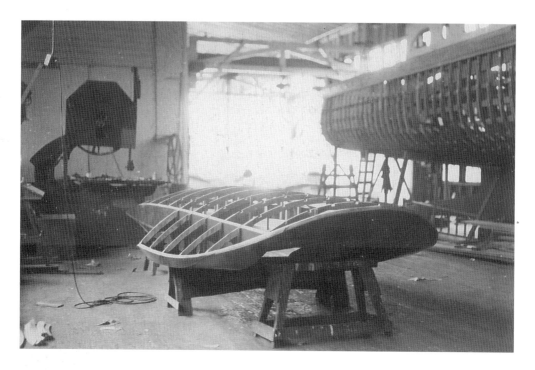

THIS 1947 PHOTOGRAPH SHOWS the *Slo-mo-shun III* under construction at Jensen's Motor Boat Company. The boat was begun at the shop at Ted's home but moved to Jensen's when building fell behind schedule. Many felt that this was the beginning of the hard feelings between Jones and Jensen. (Courtesy Jensen Motor Boats Archives.)

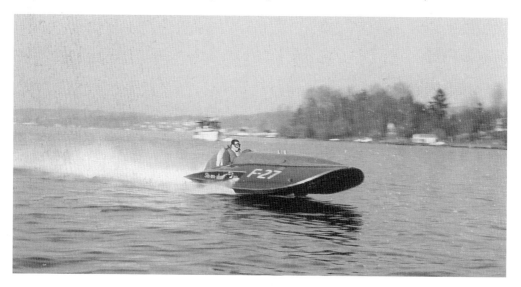

THIS VIEW SHOWS THE *Slo-mo-shun III* at speed on Lake Washington. Note the similarity between this boat and the *Avenger*. Sayres never raced this boat, but he was impressed enough with its speed and handling to go ahead with his plans for an unlimited.

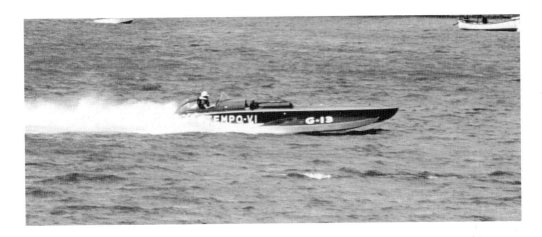

WHEN STAN, ANCHOR, AND TED went to Detroit in 1948 for the Gold Cup, several of the boats they saw were Ventnor three pointers, like this three-time Gold Cup winner *Tempo VI*, owned and driven by bandleader Guy Lombardo. (Photograph by Mel Crook.)

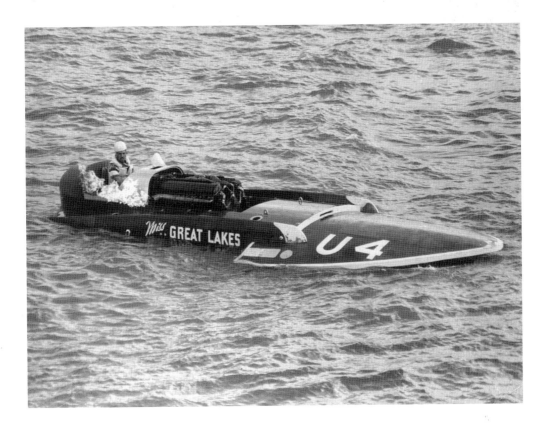

THE 1948 GOLD CUP WAS WON by Al Fallon's *Miss Great Lakes*. This Allison-powered hydro was the only boat, out of 22 starters, that finished the race. (Photograph by Jim Higgins.)

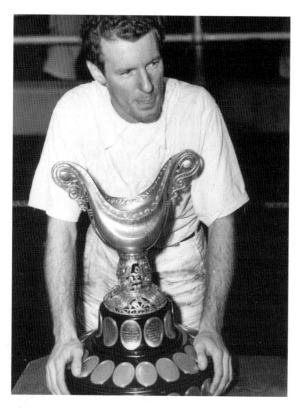

DANNY FOSTER WON THE Gold Cup in 1947 driving for the Detroit-based *Miss Pepsi* and then again in 1948, driving the *Miss Great Lakes*, also from Detroit. This would be the last time that Detroit boats would win back-to-back Gold Cups.

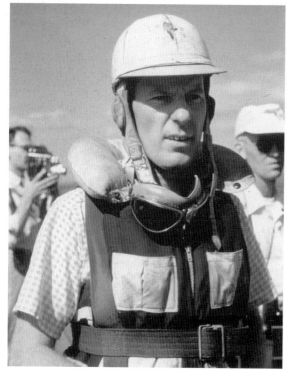

1949–1954

THE SLO-MO-SHUN YEARS

Stan, Anchor, and Ted formed a team that would lead Seattle and the sport of boat racing into new and unimaginable directions.

According to Anchor, the plan was simple: "Ted was to design the boat, I would build it, and Stan would own it." The first thing that the new Slo-mo-shun team wanted to do was get a look at the competition. Stan bankrolled a trip to the 1948 Gold Cup. That race is famous for two reasons. First, it had a record number of entries at 22, and second, only one boat, the *Miss Great Lakes*, was able to finish and even it sank before getting back to the dock! The most important thing Stan, Anchor, and Ted learned on their trip was that no matter how fast a boat was, it could not win if it did not finish. So they made reliability and consistency bywords that would define the Slo-mo-shun team for the rest of its existence.

There is tremendous controversy about who actually designed the *Slo-mo-shun IV*. Publicly Stan credited Ted, but Anchor and his supporters claim that, behind the scenes, Anchor actually did most of the work. The truth is hard to come by 50 years after the fact, but the original drawings speak volumes. Here for the first time in print are the original drawings of both Ted and Anchor. The reader can make up his or her own mind as to who should get the credit.

Construction of the *Slo-mo-shun IV* began in late 1948, and by October 1949, it was completed and launched. The boat was lighter and more aerodynamic then anything ever seen before. Stan, Anchor, and Ted spent the winter and spring of 1950 conducting an extensive testing program.

The triple crown of boat racing was the World Water Speed Record, the Gold Cup, and the Harmsworth Trophy. No boat had ever claimed all three in the same year.

In June 1950, the Slo-mo team went after the world straight away speed record. The existing mark was 141.74 miles per hour, held by Sir Malcolm Campbell of England with his Bluebird.

On June 26, the *Slo-mo-shun*, with Sayres driving and Jones in the second seat, shattered the old mark, raising it to 160.32 miles per hour. In July, with Jones driving and Mike Welsh riding mechanic, the *Slo-mo-shun* won the Gold Cup and lapped the entire field. In August, the *Slo-mo-shun* won the Harmsworth with Lou Fageol driving. The unlikely team of rookie racers from Seattle had done it. They won the boat racing triple crown on their very first attempt!

The Gold Cup was powerboat racing's premier trophy and much like the America's Cup in sailboating, the winner of the race determined where next year's race would be run. Stan Sayres wanted the 1951 race to be held in Seattle.

The idea of the Golden Potlatch from the early 1900s was revived in 1950 as Seafair, and the 1951 Gold Cup race became Seafair's premier event.

As the 1951 race neared, local sports pages and television newscasts were filled with hydroplane facts. Kids with butch-cut hairdos that had previously followed Rainers baseball or Husky football became overnight hydro experts. A large field of East Coast boats (mostly from Detroit) pledged that they were coming to Seattle to "get their cup back." Sayres then announced that in order to make the odds a little more even, he would build a second *Slo-mo-shun*. This new boat, the *Slo-mo-shun V*, was finished just days before the race.

The racecourse was located south of the I-90 floating bridge and the East Coast boats pitted out of Mount Baker Park. The two *Slo-mo-shun* boats pitted north of the bridge at Leschi Marina.

Several hundred thousand anxious Seattle fans showed up for the race. When the gun sounded for the warm-up period before the first heat, the Detroit field took to the course, but Seattle fans were worried. There was no sign of the hometown favorites. The one-minute gun sounded and the boats began to form up for the start. Seattle fans were frantic, where were their boats? With 15 seconds to go until the start of the race, the Detroit boats rounded the north turn and headed towards the line. Suddenly, from under the west high-rise of the bridge at almost 150 miles per hour, the two *Slo-mos* burst with a roar. The sound of the engines drowned out the cheers from the fans as the *Mos* flashed past the stunned Detroit drivers and grabbed the lead.

Slo-mo-shun V won the race with Lou Fageol driving. The third heat was stopped when the *Quicksilver* out of Portland, Oregon, crashed, killing driver Orth Mathiot and mechanic Thom Whittaker. Seattle and the Slo-mo team dominated Gold Cup racing for the next several years, winning in 1952, 1953, and 1954.

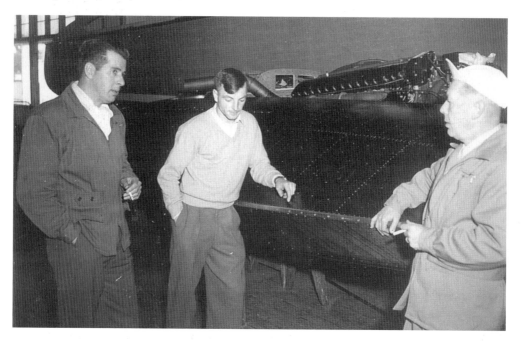

STAN SAYRES, ANCHOR JENSEN, AND TED JONES pose with the *Slo-mo-shun IV* in October 1949, shortly before the boat is launched. (Courtesy Mary Randlett.)

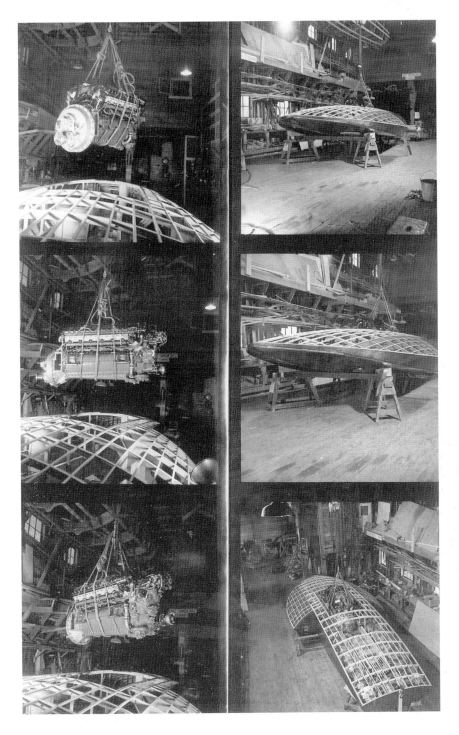

THIS MONTAGE SHOWS the motor being test fit in the partially completed *Slo-mo-shun IV*. The unique views of the boat without its deck highlight the lightweight construction that helped make the *Slo-mo-shun* so successful. (Courtesy Mary Randlett.)

No other aspect of Seattle hydroplane history has been more hotly disputed than who actually designed the *Slo-mo-shun IV*. On this page is the original drawing by Ted Jones. The drawing is undated, but Ron Jones confirms that he first saw it in 1946. The drawing on the next page is Anchor's drawing from 1948.

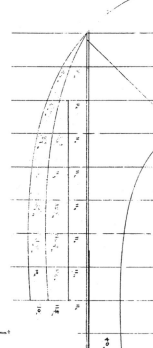

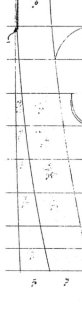

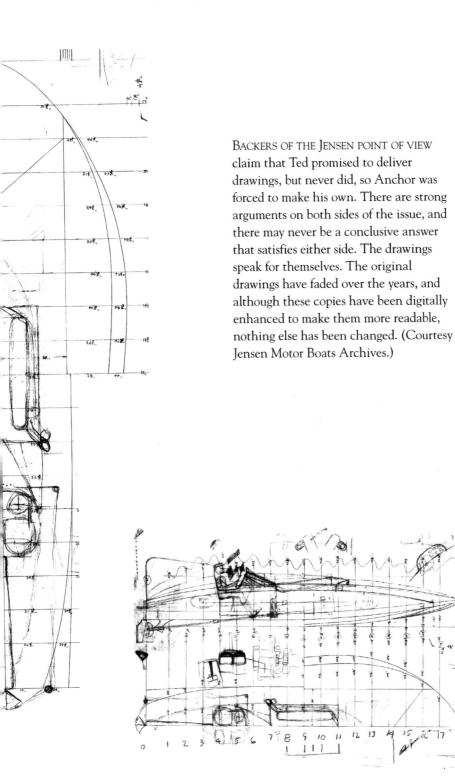

BACKERS OF THE JENSEN POINT OF VIEW claim that Ted promised to deliver drawings, but never did, so Anchor was forced to make his own. There are strong arguments on both sides of the issue, and there may never be a conclusive answer that satisfies either side. The drawings speak for themselves. The original drawings have faded over the years, and although these copies have been digitally enhanced to make them more readable, nothing else has been changed. (Courtesy Jensen Motor Boats Archives.)

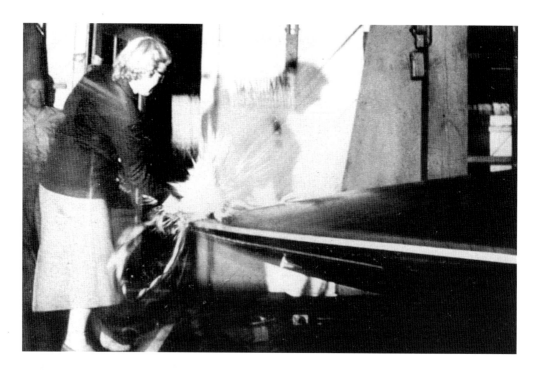

SHARON SAYRES CHRISTENS THE NEWLY completed *Slo-mo-shun IV* in October 1949. The boat took 11 months to construct. (Courtesy Mary Randlett.)

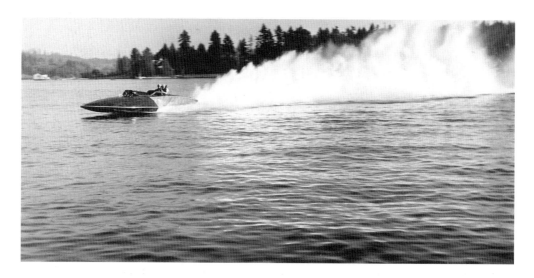

IN OCTOBER 1949, the *Slo-mo-shun IV* is at speed on Lake Washington. The tail fin, name, and numbers were added later. (Courtesy Mary Randlett.)

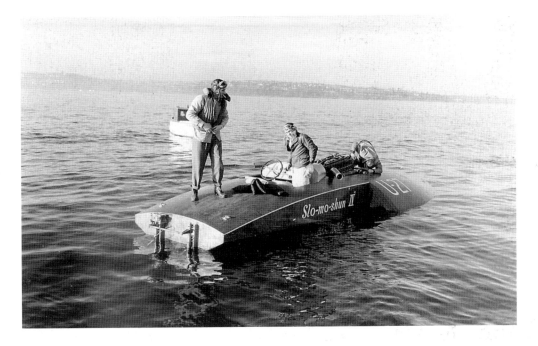

THE *SLO-MO-SHUN IV* underwent months of testing and refinement of all of the major systems and controls. This unique photograph shows the boat with twin rudders. (Courtesy Mary Randlett.)

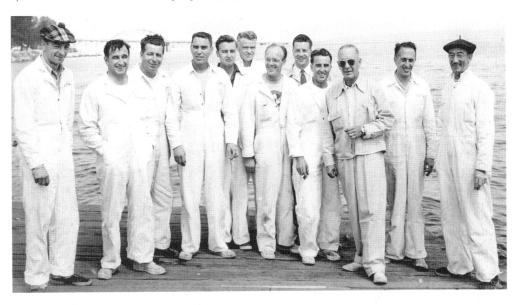

THE TRUE SECRET OF THE *Slo-mo-shun's* success was the amazingly talented crew. Pictured here, from left to right, are Anchor Jensen, Elmer Linenschmidt, unidentified, Joe Schobert, John Andrews, unidentified, Ralph Shamic, Martin Headman, Mike Welsch, Stanley Sayres, Jerry Barker, and Doc Longsburry. (Photograph by Ken Oller.)

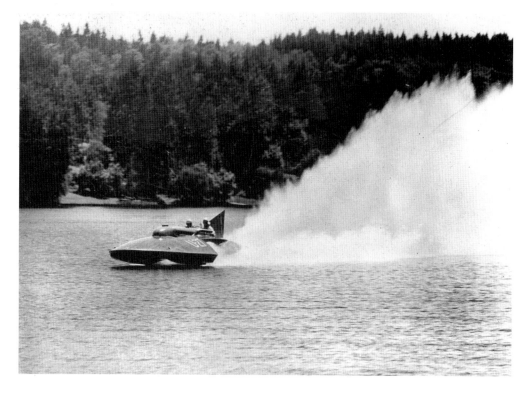

On June 26, 1950, the *Slo-mo-shun IV*, running off of Sand Point Naval Air Station with Stan Sayres driving, set a new world straight away record of 160.3235 miles per hour. (Courtesy Kent Hitchock.)

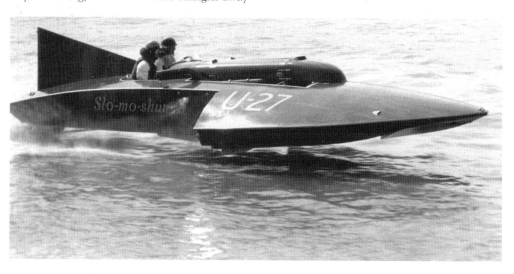

On July 22, 1950, the *Slo-mo-shun*, with Ted Jones driving, won the Gold Cup and effectively silenced all of the critics who claimed that the boat was too fragile to survive the 90-mile race. (Courtesy Jim Higgins.)

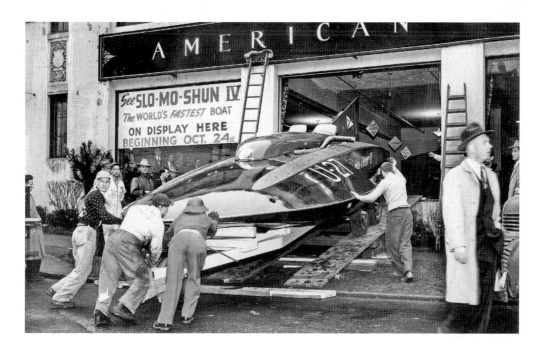

SEATTLE TREATED THE *Slo-mo-shun* and its crew as celebrities. Here the *Slo-mo-shun* is moved into the Stan Sayres Chrysler dealership on Broadway at Capitol Hill for a promotional display. (Courtesy Jensen Motor Boat Archives.)

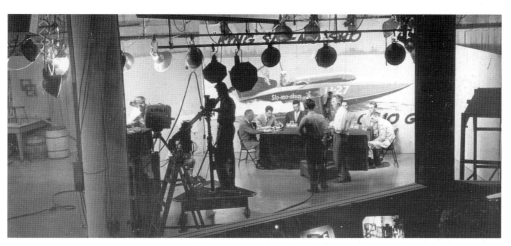

THE ENTIRE *SLO-MO-SHUN* crew was interviewed on Seattle's KING TV after the 1950 Gold Cup victory. KING began broadcasting in 1948 and had a monopoly on the Seattle market until 1953. They found that the sport made for great television and gave live coverage to both qualifying and racing. In large part, they fueled the "hydro hysteria" that overtook Seattle during the races. Pictured, from left to right, are Stan Sayres, Tom Daggett, Martin Headman, two unidentified camera operators, Joe Schobert, Mike Welch, and Anchor Jensen. (Courtesy Howard Samples.)

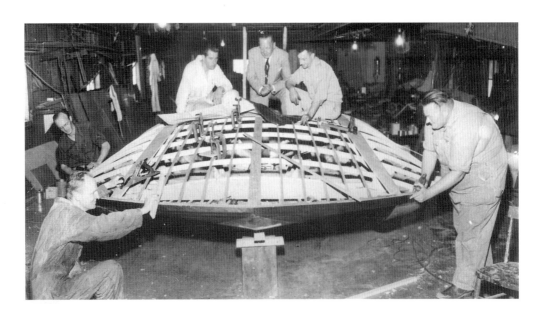

IN EARLY MARCH 1951, Stan gave the go ahead to build the *Slo-mo-shun V*. The "IV" took 11 months to build; the "V" was built in just four. Sitting in the boat are Ted, Stan, and Anchor. Working on the boat are John Andrews, Bob Swanson, and E. O. Blume. (Courtesy Jensen Motor Boat Archives.)

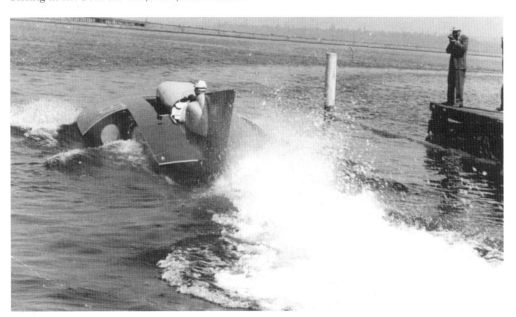

THE *SLO-MO-SHUN V* WAS finished on July 21, with much of the work being done in a whirlwind 21 days. The boat was slightly wider than the "IV" and with a bit more lift. The changes were intended to make the boat corner and accelerate better in exchange for sacrificing some top speed. (Courtesy Jensen Motor Boat Archives.)

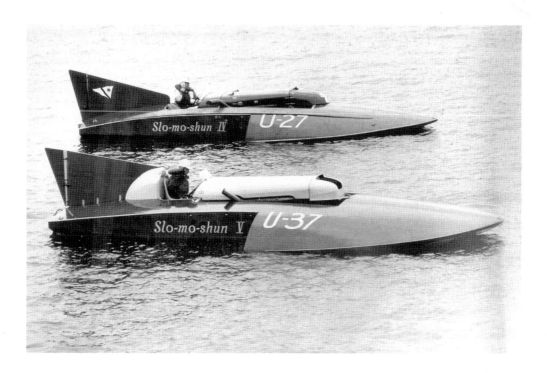

THE TWO *SLO-MO-SHUNS* made a formidable team. Veteran driver Lou Fageol drove the "V," and Ted drove the "IV." (Courtesy Ken Oller.)

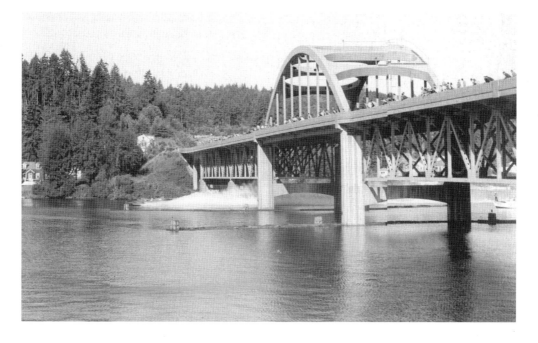

THE FLYING START FROM UNDERNEATH the I-90 bridge was a signature move for the Slo-mo-shun team. (Courtesy Jensen Motor Boat Archives.)

In 1951, a number of Detroit teams came west to try to win the Gold Cup back from Sayres and the *Slo-mo*. Many of the boats were clearly patterned after the Slo-mo. Horace Dodge Jr., heir to the automobile fortune, asked Jones to design him a new boat. Ted's contract with Sayres prohibited him from building or designing boats for anyone else, so Dodge had Bill Cantrell and Les Staduacher build him this virtual replica named *Hornet*. With Cantrell and Danny Foster sharing the driving duties, the boat took second place in the 1951 Gold Cup. (Courtesy Dave Thompson.)

Gale II, owned by Joe Schoenith, a successful electrical contractor from Detroit, made the trip to Seattle for the 1951 Gold Cup. *Gale* took a disappointing fifth place. The Gale team would play a huge part in the Seattle versus Detroit rivalry that developed over the next few years and would field more than a dozen boats in a career that spanned 25 years. (Courtesy Dave Thompson.)

IN 1951, FORMER PACIFIC COAST CHAMPION Orth Mathiot returned to racing after a 20-year retirement with his Rolls Royce–powered, John Hacker–designed step hydroplane, *Quicksilver*. Mathiot is in the rear of the boat and Thom Whitaker kneels in front of the engine. (Courtesy Dave Thompson.)

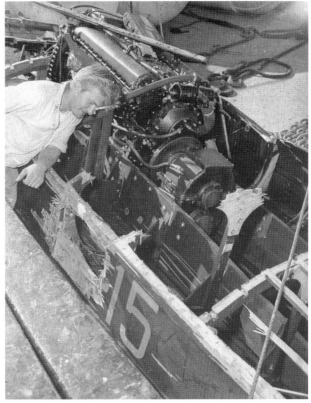

DURING THE FINAL HEAT, the *Quicksilver* crashed and killed both Mathiot and Whitaker. The race was canceled, and the damaged boat was recovered the next day. In this photograph, one of the recovery workers pauses to look at the wreckage. The *Slo-mo-shun V* was declared the winner based on the points it accumulated in the preliminary heats.

HYDROPLANE RACING IN SEATTLE

During qualifying for the 1953 Gold Cup, the *Slo-mo-shun V* lost one blade off its propeller at high speed. The out of balance shaft continued to spin, tearing a hole in the bottom of the boat. In this photograph, Lou Fageol stays with the sinking boat as it is towed back to the pits. (Courtesy Ken Oller.)

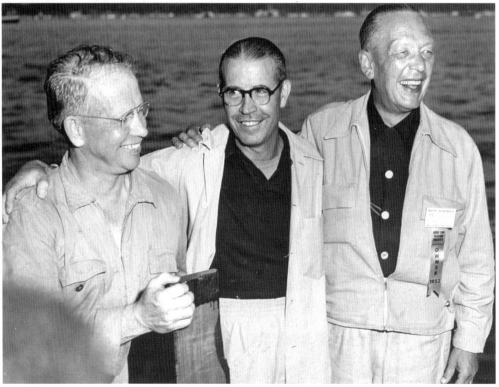

With the *Slo-mo-shun V* out of the race, Sayres had two drivers but only one boat, so he allowed Joe Taggart and Lou Fageol to share the driving duties on the *Slo-mo-shun IV*, with Joe driving the first and third heats and Lou driving the second heat. The "IV" won all three heats and the race. Here Sayres (right) celebrates the victory with Taggart (left) and Fageol (center). (Photograph by Bob Carver.)

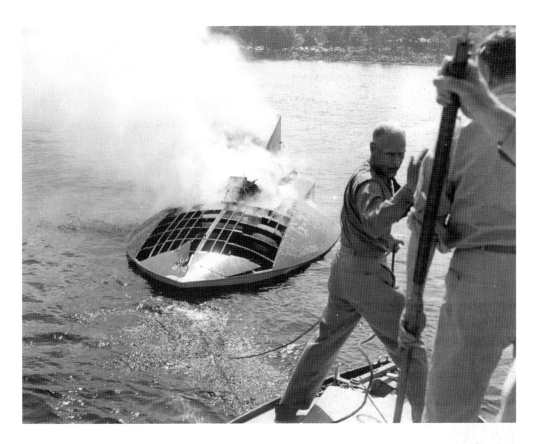

Detroit bakery owner Jack Schafer ran a series of boats named *Such Crust.* In 1952, the *Such Crust IV,* driven by Bill Cantrell, exploded during the second heat of the Gold Cup. Cantrell was seriously injured but recovered to become a significant force in the sport for decades to come. (Courtesy Bill Calhoun.)

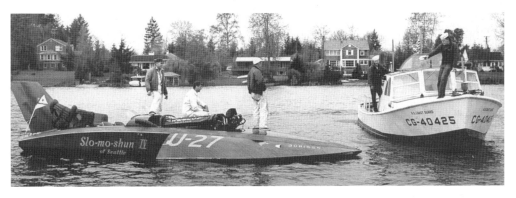

In 1953, the *Slo-mo-shun* used this unique fiberglass tail fin to promote Ballard-based FiberLay Incorporated. The promotional idea was the brainchild of a Seattle advertising agent named Bill Wurster, who would begin driving unlimiteds in 1972 and eventually buy his own unlimited team in 1976. (Courtesy Bill Calhoun.)

HYDROPLANE RACING IN SEATTLE

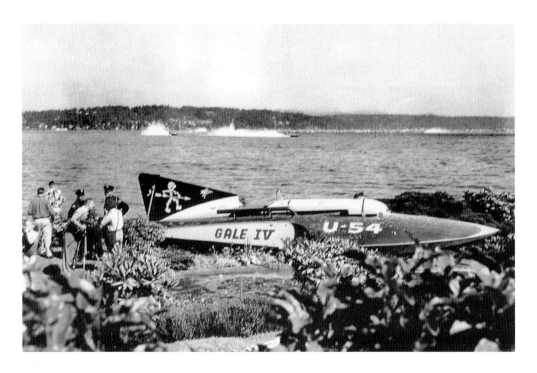

AT THE START OF THE 1954 Gold Cup, the *Gale IV*, driven by Bill Cantrell, veered out of control and landed on the beach in the middle of a rose garden. Miraculously no one was injured. The home where the *Gale IV* landed is currently owned by Art and Dorothy Oberto, longtime sponsors of Oberto Unlimited Hydroplanes.

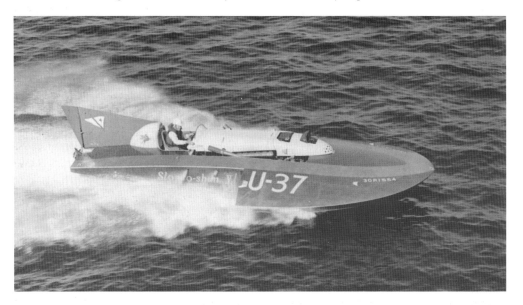

IN 1954, THE *SLO-MO-SHUN V*, with Lou Fageol driving, used a Rolls Royce Merlin engine and won the race, taking first place in all three heats. (Photograph by Ken Oller.)

3

1 9 5 5 – 1 9 6 2

BILL MUNCEY

The year 1955 saw challenges to the *Slo-mo-shun*'s dominance of Gold Cup racing. The usual large field of Detroit boats came west again, but for the first time, there were challengers from Seattle as well. Ted Jones had left the Slo-mo team in November 1951 in an acrimonious split. Jones's contract with Sayres prohibited him from building any new boats for three years. By 1955, the contract had expired and Jones teamed up with Michigan builder Les Staduacher to bring out two new boats. The *Rebel Suh*, which was co-owned by Ted Jones and Kern Armistead, and the *Miss Thriftway*, owned by Willard Rhodes and sponsored by Seattle-based Associated Grocers. The *Rebel Suh* was driven by U.S. Air Force test pilot Russ Schleeh. For the *Thriftway*, Jones had tapped talented Detroit limited racer Bill Muncey. The local papers touted the Jones-Sayres rivalry, with each side predicting victory.

The Sayres team fired off an impressive first shot when *Slo-mo-shun IV*, with Joe Taggert driving, set a new qualifying speed of 117.391 miles per hour. Not to be outdone, the *Slo-mo-shun V* crew sent Lou Fageol out in the "V" to try to top the record.

The "V" had a tendency to get flighty at high speeds, and midway through the first lap, the boat took off and flipped over backward, doing a complete loop and landing right side up. Fageol was gravely hurt, and the "V" was seriously damaged. It was later sold to Roostertails Incorporated and renamed the *Miss Seattle*.

Race day saw the *Slo-mo-shun IV* easily win the first heat, while the *Gale V* came in second, and the *Thriftway* took home third. *Thriftway* won the next heat, with *Gale V* in second, and *Slo-mo-shun* in third. In the final heat of the day, *Slo-mo* appeared to have the race wrapped up when an exhaust stack broke, catching the boat on fire. Joe Taggert shut the motor off with just two laps to go, and the *Thriftway* went on to win the heat. *Gale V* came in third. It appeared that Muncey and the *Thriftway* had won. The Seattle crowd went crazy. The Might Mo's may have been beaten, but it had taken another Seattle team to do it!

A few moments later, though, a stunning announcement was made by race officials. The victory was awarded to the *Gale V*. The *Gale's* total elapsed time for the race was 4.25 seconds faster then the *Thriftway's* total elapse time. That gave the *Gale V* 400 bonus points and the victory. Seattleites were stunned. The cup was gone, and all they could do was make plans to go to Detroit the next year and win it back.

Seafair needed a race to take the Gold Cup's place in 1956, so the Seafair Trophy was upgraded from its role as a second feature to fill the bill. The race was a huge success with 17 boats and 500,000 fans showing up. A new Ted Jones boat, the *Shanty I*, owned by Bill Waggoner and driven by Russ Schleeh, won the race, with *Slo-mo-shun IV* taking second.

By 1956, Gold Cup competition had evolved in to a civic rivalry between the boat-racing establishment based in Detroit and the upstarts in Seattle. More than a half dozen Seattle boats made the cross-country journey to Detroit. The race was a hard-fought contest that saw the *Slo-mo-shun IV* destroyed in a pre-race qualifying attempt and the *Miss Thriftway* win the final heat and apparently the race. As the Seattle teams began to celebrate their victory, the PA announced that the *Miss Thriftway* had been disqualified for striking a buoy and that the victory was being awarded to the *Miss Pepsi* of Detroit.

It was more than the Seattle teams could stand! *Miss Thriftway* owner Willard Rhodes challenged the judge's decision and used film from Seattle's KING TV to prove that the *Miss Thriftway* did not strike the buoy. Muncey and the *Thriftway* were eventually awarded the trophy, but the rivalry between Seattle and Detroit had turned ugly. For the next decade, unlimited racing would be defined by the fierce competition between the two cities.

The 1957 Gold Cup was held in Seattle, and for the third year in a row, Bill Muncey brought the *Miss Thriftway* off the course and back to the dock believing that he had won the race. This year there was to be no bitter announcement, the *Thriftway* had won fair and square, and there were no challenges.

IN SPRING OF 1955, STAN SAYRES found that he had local competition. In this staged photograph for the *Seattle Post Intelligencer*, Sayres and Willard Rhodes, owner of the *Miss Thriftway*, have a friendly tug of war for the Gold Cup while Con Knudson looks on. (Courtesy *Seattle Post Intelligencer*.)

1955–1962: BILL MUNCEY

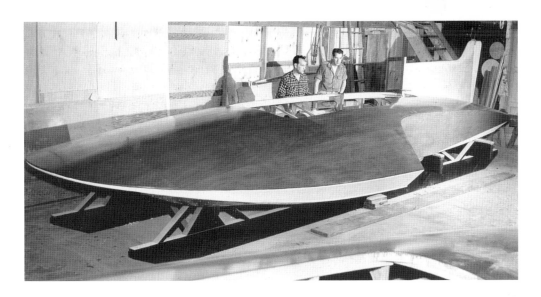

In 1955, Ted Jones hired Michigan boat builder Les Staduacher to build two new boats from his plans. The first was *Rebel Suh*, co-owned by Ted Jones and Kern Armistead. The second was *Miss Thriftway*, owned by Willard Rhodes and sponsored by Seattle-based Associated Grocers. Here Ted and Les inspect the *Miss Thriftway*. (Photograph by Elmer H. Pincombe.)

Jones managed both new teams, choosing rookie drivers for both boats. Col. Russ Schleeh was tapped to drive the *Rebel Suh* and young Detroit limited star Bill Muncey was hired to drive the *Miss Thriftway*. (Photograph by Bob Carver.)

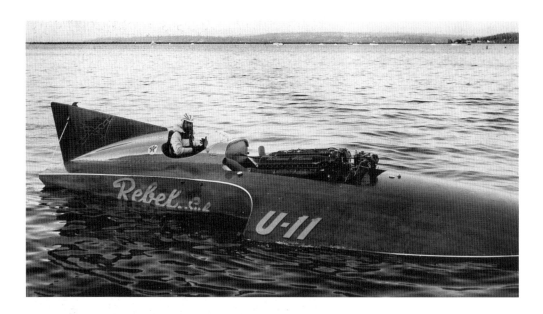

IN THIS RARE PHOTOGRAPH, Russ Schleeh returns from a test run in the *Rebel Suh*. The boat was very fast but lost a piece of its bottom during the first heat of the 1955 Gold Cup and sank before showing its true potential. (Courtesy Bruce Calhoun.)

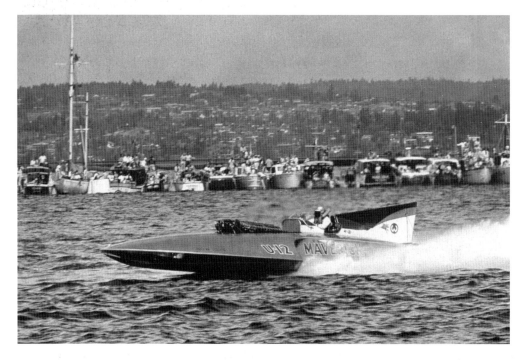

IN 1956, THE *REBEL SUH* was sold to Bill Waggoner and renamed *Maverick*. With Bill Stead driving, the boat won several races before being destroyed by fire during a test after the end of the 1958 season. (Photograph by Bob Carver.)

LEE SCHOENITH WAS ACTUALLY a close friend of Bill Muncey. They both grew up in Detroit with similar backgrounds and interests, but during the heyday of the Seattle-Detroit rivalry, the two kept up the public appearance of a feud to keep media and fan attention focused on the sport.

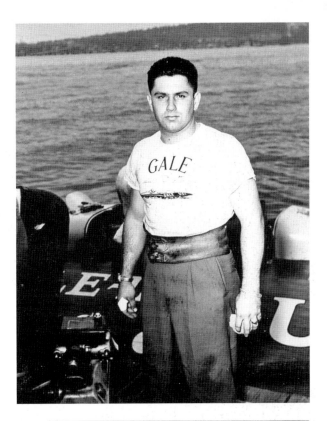

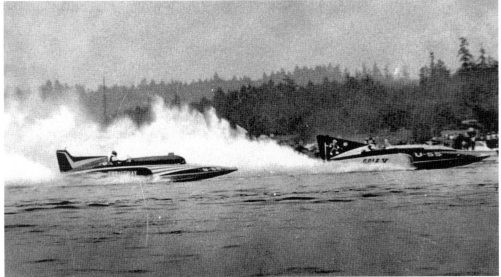

AN INEXPERIENCED BILL MUNCEY had the 1955 Gold Cup wrapped up but allowed it to slip away when he slowed dramatically on the final lap, allowing the *Gale V*, driven by Lee Schoenith, to post a faster elapsed time and earn 400 bonus points to claim the victory. This photograph shows the two boats battling in the first heat.

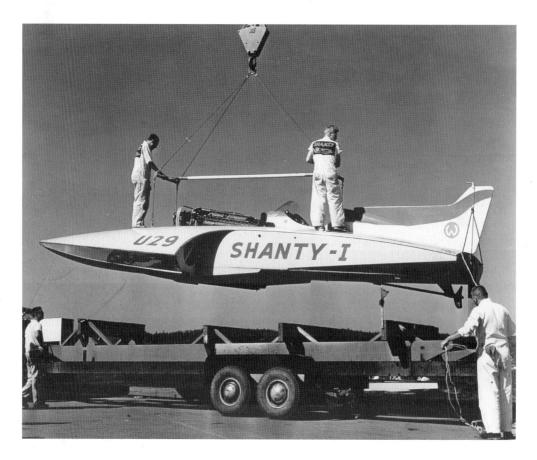

IN 1956, TEXAS MILLIONAIRE cattle rancher Bill Waggoner bought an exact duplicate of the *Miss Thriftway* from Jones. Waggoner named the boat *Shanty* after his wife. With Russ Schleeh driving, the new boat was a winner right out of the box, winning its first three races, including the 1956 Seafair race and the national championship. (Courtesy Bruce Calhoun.)

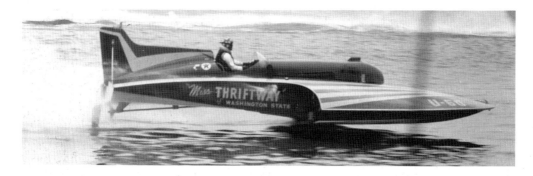

MUNCEY AND THE *Miss Thriftway* captured the Gold Cup in Detroit after challenging officials who claimed that Muncey had struck a buoy in the final heat. Film supplied by Seattle's KING TV showed that Muncey cleanly rounded the buoy in question. (Photograph by Hal Stine.)

WHEN MUNCEY RETURNED TO SEATTLE after winning the 1956 Gold Cup, he was given a hero's welcome.

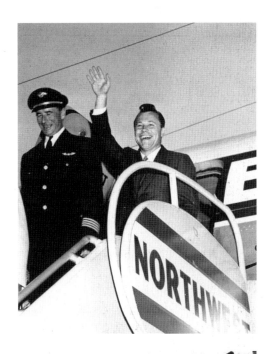

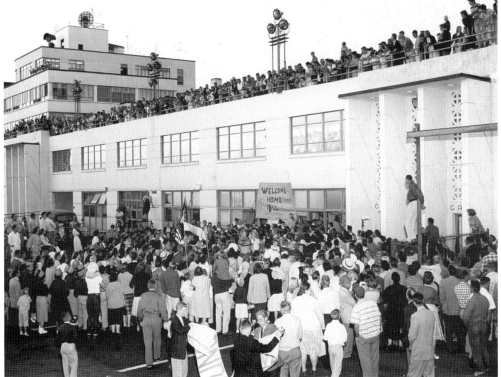

TENS OF THOUSANDS OF PEOPLE turned out at the old SeaTac Airport terminal to greet Muncey and the Miss Thriftway team when they arrived back in town.

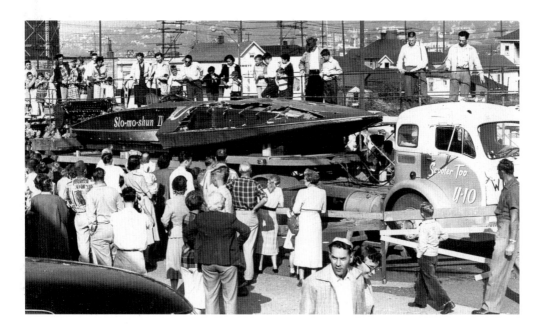

DURING TESTING BEFORE THE 1956 Gold Cup in Detroit, the *Slo-mo-shun IV* hit the wake from a patrol boat and crashed, seriously injuring driver Joe Taggart and destroying the boat. The wreckage of the boat was returned to Seattle in early September and placed on display in the KING TV parking lot. Thousands of fans came to pay last respects to "their" boat. A few days later on September 17, 1956, Stan suffered a fatal heart attack. (Photograph by Bob Carver.)

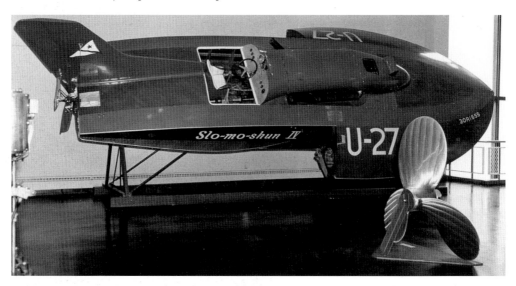

WITH MONEY DONATED BY HENRY KAISER and Stan Dollar, Anchor Jensen and the Slo-mo-shun crew rebuilt the *Slo-mo-shun IV* and donated it to the Museum of History and Industry in 1959.

1955–1962: BILL MUNCEY

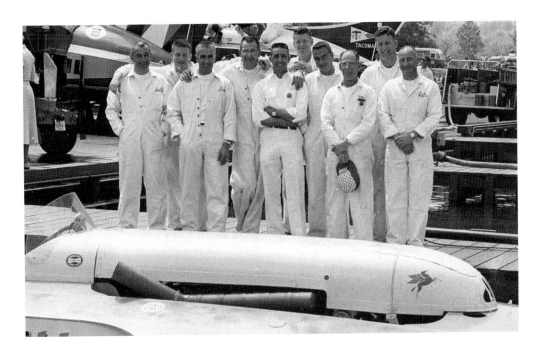

AFTER THE *SLO-MO-SHUN* WAS DESTROYED, the Slo-mo crew found themselves without a boat to work on. Starting with the Rogers Memorial race in Washington, D.C., on September 19, 1956, Edgar Kaiser brought them onto the Hawaii Kai team, and immediately the boat began to win. The *Hawaii Kai* won the Rogers Memorial and closed out 1956 with a victory in the Sahara Cup in Las Vegas. In 1957, it won five more races and the national championship. The crew, pictured here at the 1957 Gold Cup in Seattle, from left to right, is Elmer Linenschmidt, Jack Watts, Mike Welch, George Mckernan, Jack Regas, Don Ibsen, Rod Fellers, Wes Kiesling, Fred Hearing, and Pete Bertellotti. (Photograph by Bob Miller.)

TED JONES DESIGNED A NEW, rear engine boat for the Thriftway team. The radical *Thriftway Too* never quite lived up to expectation but became a fan favorite for its unique looks. Here Ted Jones brings the boat back from its first run.

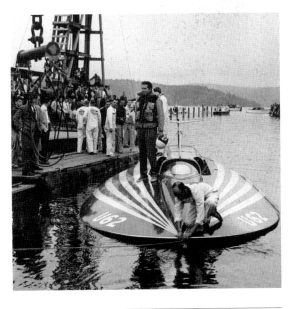

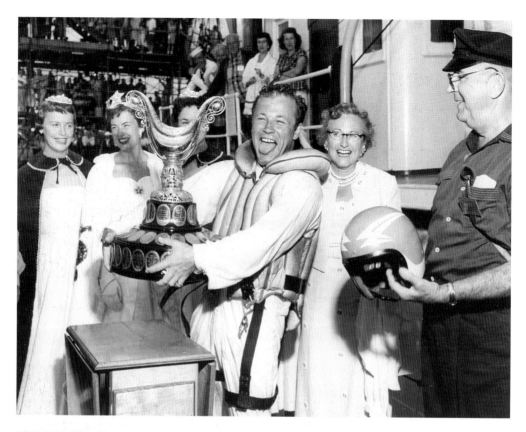

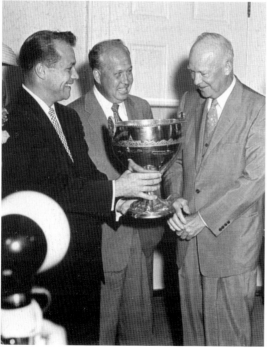

MUNCEY AND THE MISS THRIFTWAY won the 1957 Gold Cup in Seattle. For the first time in his career, the victory was clear and undisputed.

THE THRIFTWAY TEAM CONTINUED their winning ways, capturing the 1956 President's Cup trophy in Washington, D.C. In this photograph, Bill Muncey and boat owner Willard Rhodes receive the trophy from Pres. Dwight Eisenhower at the White House.

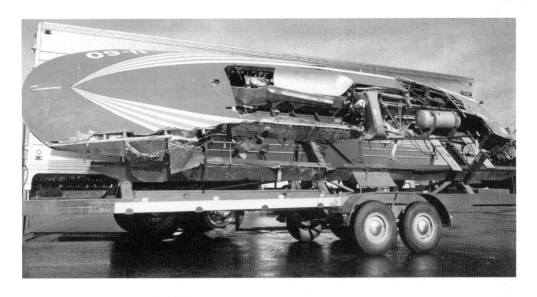

ALL GOOD THINGS MUST come to an end and Miss Thriftway's career ended in Madison, Indiana, in 1957. The boat lost its left sponson during the second heat of the Governor's Cup. (Courtesy Associated Grocers.)

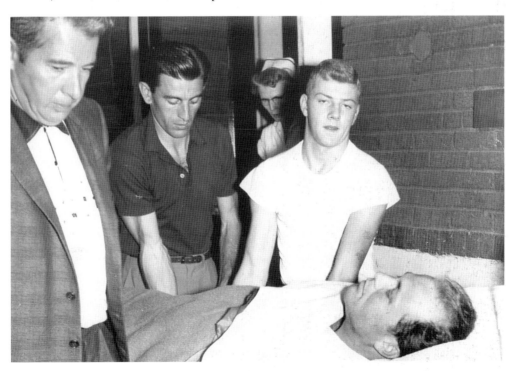

MUNCEY WAS SERIOUSLY INJURED when the Miss Thriftway crashed, and he was flown back to Seattle for recovery. In this photograph, Ted Jones and Mira Slovak accompany Muncey, on the stretcher, from the hospital in Madison.

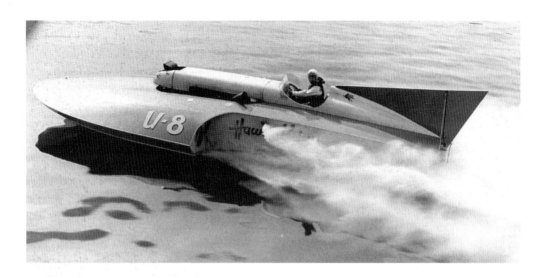

THE HAWAII KAI TEAM CAPPED OFF THEIR national championship winning season by setting a new world speed record of 187.627 miles per hour for a mile and 195.329 miles per hour for a kilo. They had a one-way run in the kilo of 200.442 miles per hour. The only trophy they were missing was the Gold Cup, and in 1958, they took care of that, winning all three heats on their way to a sentimental victory on Lake Washington in August 1958. Kaiser immediately retired from racing. (Photograph by Bob Miller.)

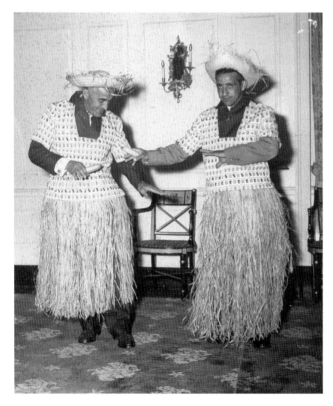

THE *HAWAII KAI* WAS NAMED after a real estate development in Hawaii owned by Edgar Kaiser. The boat's logo was a hula girl. Here crew chief Mike Welch and driver Jack Regas give a reluctant hula exhibition at the Seattle Yacht Club.

1955–1962: BILL MUNCEY

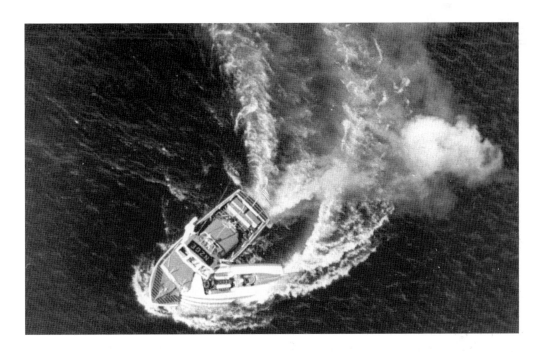

SHORTLY AFTER THE START OF HEAT 2-A in the 1958 Gold Cup, the *Miss Thriftway* lost its rudder and hit a Coast Guard cutter. (Photograph by John Vallentyne.)

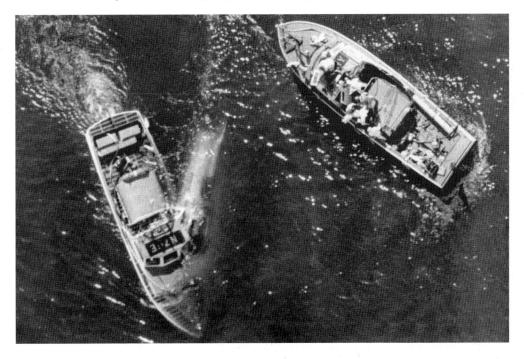

BOTH BOATS IMMEDIATELY SANK. Miraculously no one was seriously injured. (Photograph by John Vallentyne.)

THE 1959 GOLD CUP was a closely fought contest, with a disputed outcome. It appeared that Bill Muncey and the *Miss Thriftway* had won the race, but officials determined that the *Miss Spokane* jumped the gun so it was penalized one lap in the final heat, which moved Bill Waggoner's *Maverick* up from fourth place to third place, and put the *Maverick* and *Thriftway* into a points tie. But the *Maverick* had the faster elapsed time and was declared the winner. This photograph shows the start of the controversial final heat. The *Miss Spokane*, on the inside lane, leads the field to the line.

BILL STEAD DRIVES THE *MAVERICK* to victory in the 1959 Gold Cup. Bill Waggoner, the winning owner, elected to hold the 1960 Gold Cup in Las Vegas, but bad weather forced the race to be canceled after the first heat. Since there was no 1960 winner, the site for the 1961 Gold Cup was determined by the highest bidder. Reno, Nevada, won the honor. The race in Reno was won by Bill Muncey and the *Miss Thriftway*.

1955–1962: BILL MUNCEY

AFTER A DISAPPOINTING 1959 SEASON, the Thriftway team started out February 1960 by setting a world water speed record on Lake Washington. Muncey and the *Thriftway* reached 192.001 miles per hour for the measured mile. In 1961, the Miss *Thriftway* changed its name to Miss *Century 21* to promote the Seattle World Fair. The new name did nothing to slow the boat down, and it went on to win the Gold Cup and national championship in 1961 and 1962. (Photograph by Jerry Bryant.)

WHEN THE HYDROS FIRST BEGAN to race in Seattle, they pitted out of Mount Baker Park and Leschi Marina. In 1957, the Stan Sayres pits were opened to give the hydros a permanent first-class pit facility. This photograph, taken in 1962, shows the distinctive finger piers that are recognized across the nation as Seattle's Stan Sayres Pits. (Photograph by Rutherford Hayes.)

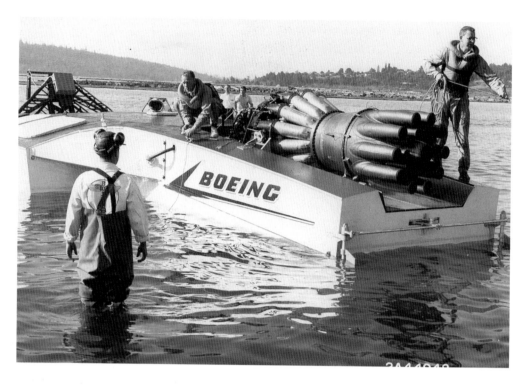

IN THE EARLY 1960S, EVERYONE in Seattle was getting in to the hydros. Boeing designed this jet-powered, pickle-forked twin cockpit hydro to test foils for their new hydrofoil project.

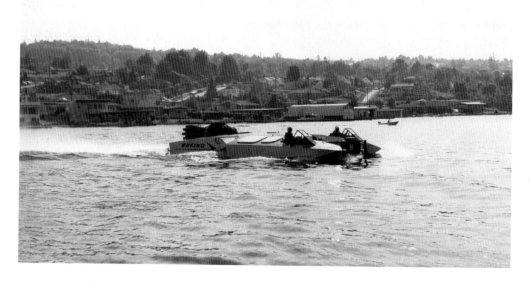

BUILT BY BLANCHARD BOAT COMPANY in 1961, the *Boeing HTS* had a driver in one cockpit and an observer in the other. The unique fork bow allowed engineers to hang various hydrofoil shapes in the water between the two forks and observe and record their effectiveness.

4

1963–1968

MISS BARDAHL

Willard Rhodes announced that Miss Thriftway would retire at the end of 1963. Fans wondered if any team could dominate the sport the way that Muncey and the Thriftway had.

They did not wonder long. Ole Bardahl's Miss Bardahl won the first race of the 1963 season and went on to win the Gold Cup and national championship three years in a row! The Bardahl was driven by Ron Musson, and he quickly replaced Muncey as the sport's premier driver.

Married to Ole's daughter Evelyn, Rex Manchester drove the Notre Dame. Another popular team was the one for Miss Exide, driven by Bill Brow. At the end of the 1965 season, the Exide was sold to Bernie Little and became the third Miss Budweiser. Two other top boats were the Tahoe Miss, owned by Bill Harrah of Harrah's Casino, and the Miss Smirnoff, owned by Lee Schoenith.

Bardahl retired the national champion Miss Bardahl at the end of 1965 and brought out a new rear engine boat for 1966. The new Bardahl was designed by Ted Jones's son, Ron.

The first race was in Tampa, and the new Bardahl qualified fast but withdrew because of mechanical problems. The next race was the President's Cup Regatta in Washington, D.C. Bardahl was fastest qualifier and won its Saturday heat. Notre Dame also won its Saturday heat. The boats were tied going into Sunday's racing.

Bardahl and Notre Dame were drawn in the same heat on Sunday. They crossed the line together with Bardahl on the inside. Moving up the backstretch, Bardahl held a slight lead. Passing National Airport, the Dame edged ahead. As they completed lap one, the Bardahl lost a blade from its propeller, dove nose first into the river, and exploded into a shower of bits and pieces. Rescue divers raced to the scene. Ron was rushed to the hospital, but he was declared dead on arrival.

Back in the pits, people were in shock. The sport's biggest star was gone in an instant. There was talk of canceling the race, but the drivers voted to go on. The heat was rerun and the Notre Dame won easily. Rex held a 100-point lead over the second place Miss Budweiser.

As the boats prepared for the final heat, Rex was seen wiping tears from his eyes. At the start, Budweiser took the lead on the inside. Midway up the backstretch the Dame pulled even, then slightly into the lead. Suddenly, at 160 miles per hour, the Dame bounced wildly three times and landed squarely on top of the Budweiser on the third bounce. The Bud plowed through the underside of the Dame, throwing Rex from the boat and crushing Don instantly.

As the spray settled, rescue workers rushed to the scene. Don's body was pulled aboard a Coast Guard boat, covered with a brown blanket, and brought back to the dock. Rex was thrown so far from that accident that it took the divers several moments to find him. Rex was carried back to the dock crumpled in the bow of a small fiberglass boat. He was placed on a gurney a few

feet from Don as overwhelmed rescue crews struggled to save both men. Ambulances rushed away with sirens screaming. Fans knelt to pray, while crewmen went through the motions of getting the boats back on the trailers. The rest of the day's racing was canceled. News came from the hospital that both Don and Rex had died, too. In an ironic twist of fate, when the race was canceled, Rex and the *Notre Dame* were declared the winners based on the points they accumulated in the earlier heats. Rex finally won a race, but unfortunately, he wasn't there to accept it.

Two weeks later on the Fourth of July, the boats raced in Detroit for the Gold Cup. Drivers put on a good face, but there were shadows across their smiles. Heat 3-A pitted Chuck Thompson in the *Smirnoff* against the *Tahoe Miss*. The boats hit the line together with the *Smirnoff* in lane one and in the lead. As the boats accelerated up the straightway, the *Smirnoff* bounced, rocked up on its side, and disintegrated. Once more, the crews held their breath, and once more, the news was grim. Chuck Thompson was dead. In two weeks, the sport had lost four of its greatest drivers.

Seattle was rocked by the news. Hydroplane racing had enjoyed unbelievable popularity, but the winds began to shift. The sport's innocence was gone and the honeymoon was officially over.

Racing continued, attendance was high, but the media began to question if such a violent sport had a place in Seattle. In 1967, Bardahl came back with a new boat and new driver. In 1967 and 1968, Billy Schumacher won back-to-back Gold Cups and national championships for Ole Bardahl aboard the new *Miss Bardahl*.

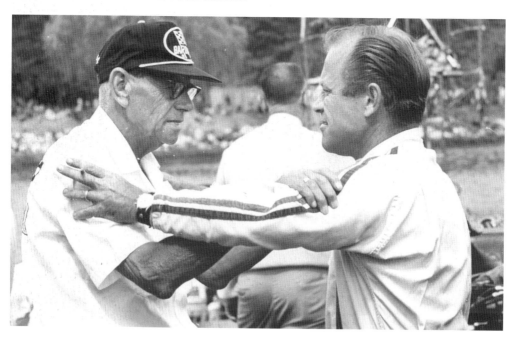

BETWEEN 1956 AND 1962, Bill Muncey won four Gold Cups driving the *Miss Thriftway*. Between 1963 and 1968, Ole Bardahl won five as an owner of *Miss Bardahl*. Here Muncey and Bardahl greet each other in the Seattle pits. (Photograph by Pete Kinch.)

WITH THRIFTWAY'S RETIREMENT from the sport, Bill Muncey had to find other ways to keep busy on race day. Here Muncey proudly wears the uniform of ABC's Wide World of Sports. Muncey was successful as a broadcaster and continued to work with ABC and Seattle's KING TV, even after he returned to racing.

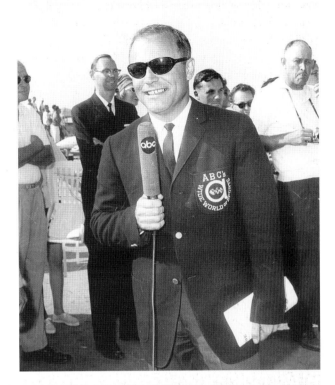

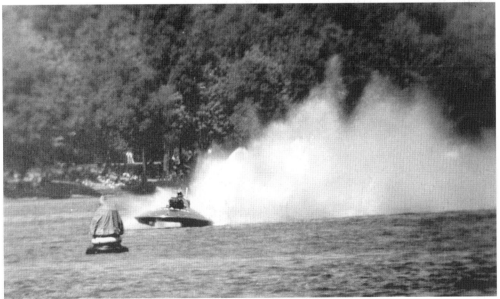

THE THIRD *MISS BARDAHL*, DESIGNED AND BUILT by Ted Jones in 1962, became the dominant boat of the mid-1960s, winning the Gold Cup and national championship three years in a row—1963, 1964, and 1965.

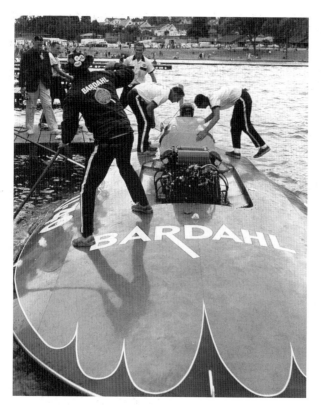

THE SECRET OF BARDAHL'S SUCCESS was its young and talented crew. Pictured, from left to right, are Dave Smith (on the dock), Jerry Zuvich (stepping between the boat and dock), Leo Vanden Berg (leaning over the cockpit from the left), Ron Musson (in the cockpit), and Dax Smith (leaning in from the right). Gary Breakfield has his back to the camera.

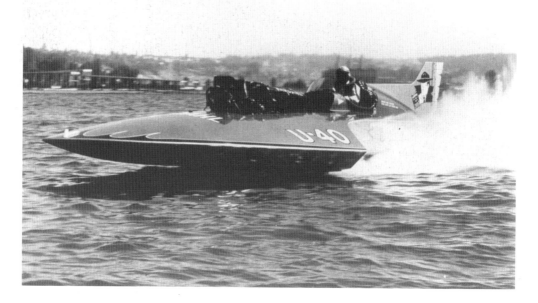

THE MISS BARDAHL WAS FAST and very reliable, running the entire 1964 and 1965 seasons without posting a single DNF (did not finish). (Courtesy Bardahl Oil Company.)

1963–1968: MISS BARDAHL

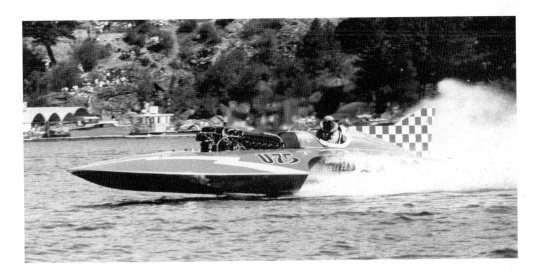

ONE OF THE LAST UNLIMITED HYDROPLANES designed by Ted Jones was the 1963 *Miss Exide*. The boat was built by Seattle's talented Ed Karelsen and driven by Mira Slovak. Slovak was a cold war hero, who defected from communist-controlled Czechoslovakia in the 1950s. (Photograph by Bob Carver.)

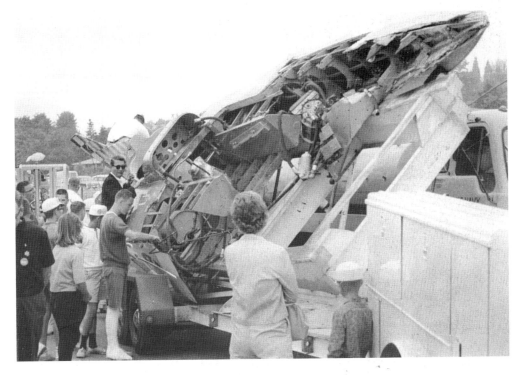

THE *EXIDE* DID NOT LAST LONG. In only its second race, it nosed in and was totally destroyed, seriously injuring Slovak. This photograph shows the damaged hull displayed outside the pits at the 1963 Seafair race.

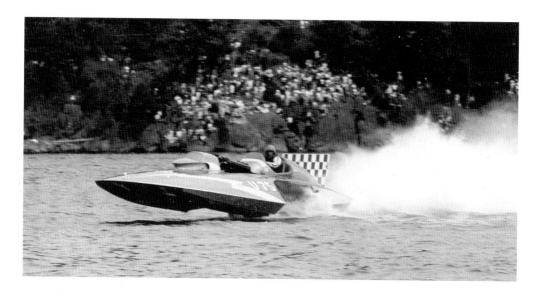

THE SECOND *EXIDE* WAS BILL BOEING'S former *Wahoo*, brought out of retirement. A milkman from Burien named Bill Brow took over as driver. Brow, who was dubbed "The World's Fastest Milkman" by the local media, was instantly a fan favorite. (Photograph by Bob Carver.)

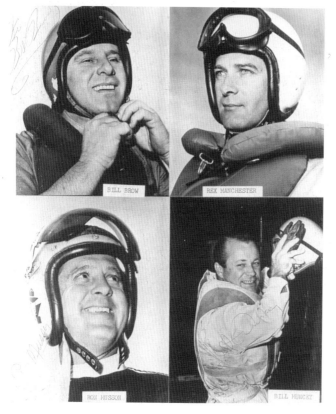

BY 1965, THERE WERE no bigger sports stars in Seattle than Bill Brow, Rex Manchester, Ron Musson, and Bill Muncey. All four drivers would be killed by the sport they loved. Ron and Rex in Washington, D.C., on Black Sunday, June 19, 1966. Bill Brow died one year later on June 11, 1967, when the *Miss Budweiser* crashed in a race in Tampa, Florida. Muncey died in Acapulco, Mexico, when his *Atlas Van Lines* crashed in October 1981. (Courtesy Unlimited Racing Commission.)

IN 1965, RON JONES designed and
built a radical rear engine *Miss
Bardahl* for Ole Bardahl. The
fourth *Miss Bardahl* was supposed
to race in 1965, but a delay in the
manufacturing of its gearbox forced
the team to postpone the new
Bardahl's debut until 1966. This
photograph shows Ole Bardahl and
Ron Musson posing in front of the
brand new boat upon its arrival at
the Bardahl shop. (Courtesy Museum
of History and Industry, *Seattle Post
Intelligencer* collection.)

A SMILING RON MUSSON prepares to
take the *Miss Bardahl* out for a test
run in early 1966. (Courtesy Museum
of History and Industry, *Seattle Post
Intelligencer* collection.)

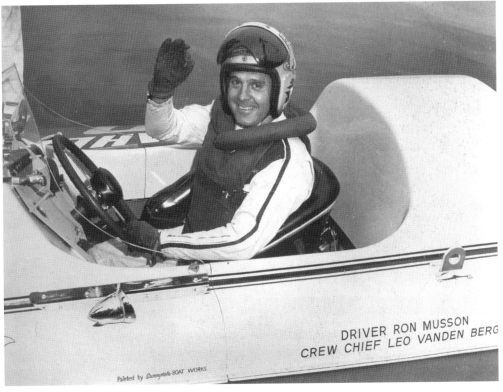

DRIVER RON MUSSON
CREW CHIEF LEO VANDEN BERG

Painted by *Sunnydale* BOAT WORKS

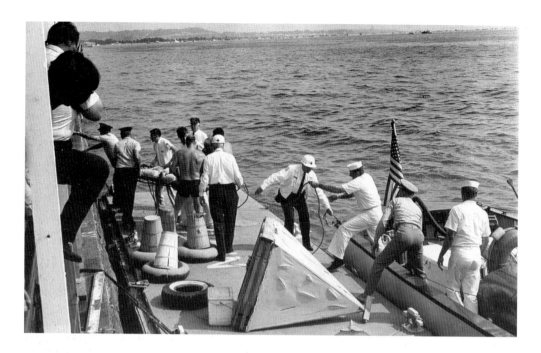

IN A SCENE THAT WAS REPEATED FOUR TIMES in the dreadful summer of 1966, rescue workers hurry to give medical attention to a mortally injured driver. This photograph shows Ron Musson being moved from a Coast Guard boat to a waiting ambulance. (Courtesy National Park Service, U.S. Department of the Interior.)

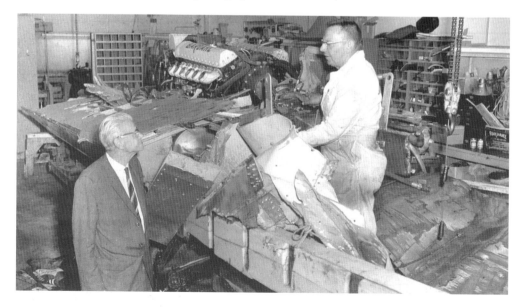

CREW CHIEF LEO VANDEN BERG stands in the remains of the shattered *Miss Bardahl*, while Ole Bardahl looks on. (Courtesy Museum of History and Industry, *Seattle Post Intelligencer* collection.)

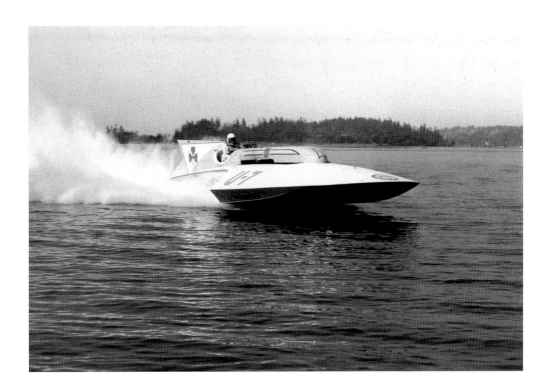

THE BLUE AND WHITE *NOTRE DAME* was one of the most beautiful boats on the circuit. Although it was fast, it was plagued by mechanical problems and just plain bad luck and never lived up to expectations. (Photograph by Bob Carver.)

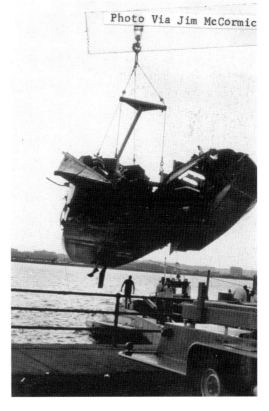

Photo Via Jim McCormic

REX MANCHESTER NEVER WON A RACE while he was alive, but when the *Notre Dame* he was driving in the 1966 President's Cup collided with the *Miss Budweiser* driven by Don Wilson, killing both Rex and Don, the race was canceled and Rex was awarded the victory based on points accumulated earlier in the day. Here the shattered remains of the *Notre Dame* are pulled from the water the Monday morning after the race. (Photograph by Jim McCormick.)

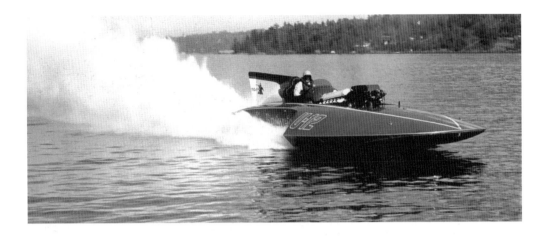

BILL BOEING'S WAHOO, BUILT IN 1956, became the second *Exide* in 1963 and then the fourth *Miss Budweiser* in 1966. Bill Brow moved from the *Exide* to the *Budweiser* and drove the first race in 1966, but a broken wrist kept him out of the cockpit in Washington, D.C. Veteran Don Wilson was hired to take his place.

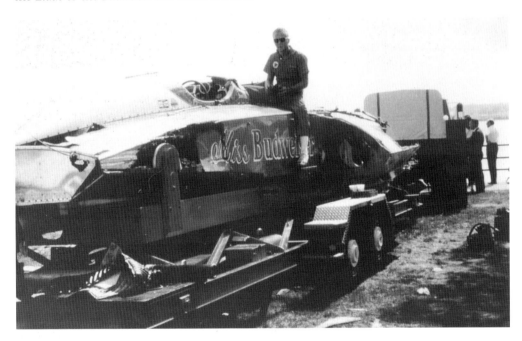

DON WILSON WAS BILL MUNCEY'S college roommate and began driving unlimiteds in 1955. In Washington, D.C., Wilson was filling in for an injured Bill Brow. The race took place on Father's Day, and Wilson, knowing that his father was listening to the race on radio, asked announcer Jim Hendrick to wish his dad a happy Father's Day at the start of the final heat. Moments after Hendrick gave the Father's Day greeting, the *Notre Dame* careened out of control, landing on top of the *Budweiser* and killing both Rex Manchester and Don Wilson. (Photograph by Jim McCormick.)

1963–1968: MISS BARDAHL

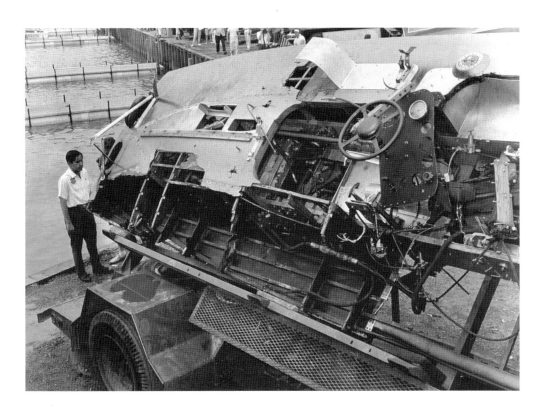

THE CARNAGE CONTINUED INTO the next race. During the Fourth of July weekend at the Gold Cup in Detroit, the *Smirnoff*, owned by Joe Schoenith and driven by Chuck Thompson, crashed, killing Thompson. In this photograph Jerry Schoenith inspects the shattered remain of the *Smirnoff*.

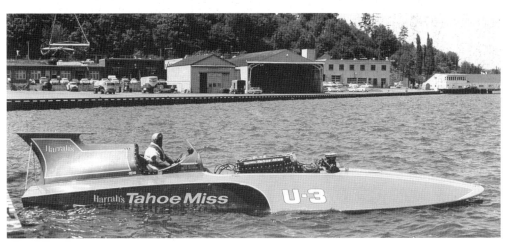

CHUCK THOMPSON HAD DRIVEN the *Tahoe Miss* in 1965 but was fired at the end of the season. Mira Slovak took over the ride for 1966 and won the Gold Cup, as well as the national championship. (Courtesy of Dixon Smith.)

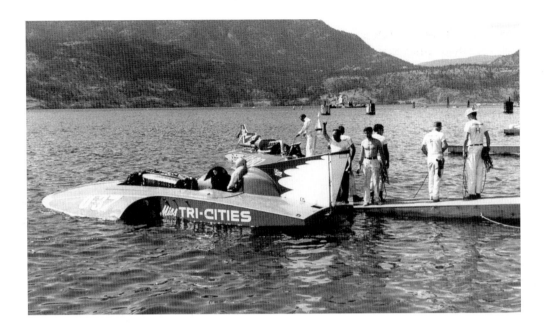

THE LAST CHAPTER OF THE SLO-MO-SHUN saga was written in 1966. The mighty *Slo-mo-shun V* returned to competition as the lowly *Miss Tri-Cities*. The boat traveled to four races, collected 1,071 points, and finished 17th in the National High Points standing. The boat would not be on the water again until 1993, when the Hydroplane and Raceboat Museum restored the boat to running condition and took it to Seafair for a running exhibition. (Courtesy Doug Shultes.)

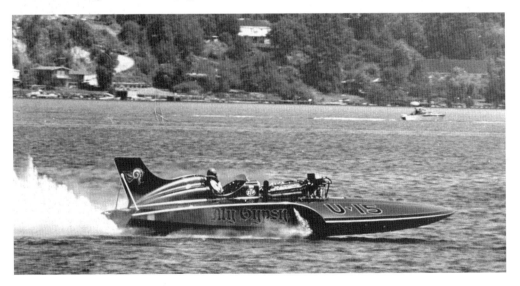

JIM RANGER WAS THE OWNER AND DRIVER of the *My Gypsy*, and his victory at Seafair was the last victory by a sportsman owner/driver in the sport's history. Ranger's boat was named after his wife Yvonne's nickname.

1963–1968: MISS BARDAHL

AFTER THE TRAGIC 1966 SEASON,
Ole Bardahl returned to the sport
with a new boat and a new driver.
Twenty-four-year-old Bill "The Kid"
Schumacher had tested the rear
engine *Miss Bardahl* and was the
logical choice to fill the void left
by Ron Musson's death. (Courtesy
Bardahl Oil Corporation.)

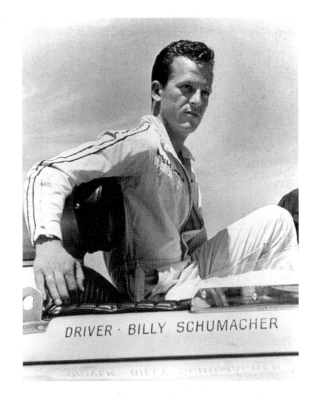

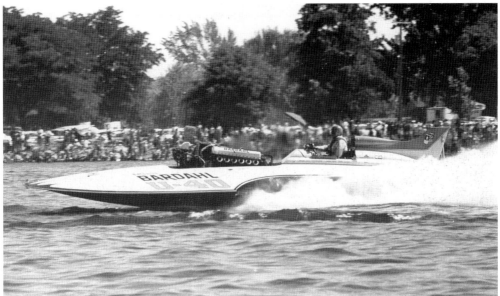

ED KARELSEN DESIGNED AND BUILT the fifth *Miss Bardahl*. Ted Jones had been critical of Karelsen's construction techniques when the 1963 *Exide* that Karelsen built crashed in its second race. Ed was vindicated when the new *Bardahl* won six out of the eight races it entered, including the Gold Cup and national championship. (Photograph by Bob Carver.)

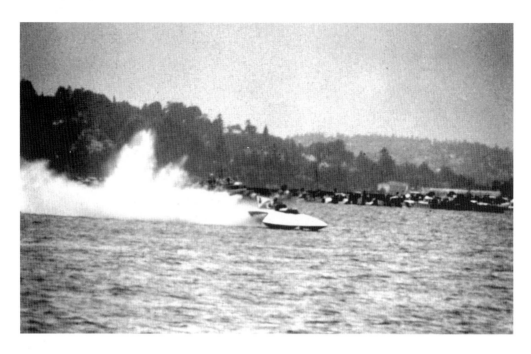

THE 1967 GOLD CUP IN SEATTLE got off to a frightening start. When the boats crossed the starting line for heat 1-A, the *Notre Dame*, driven by Jack Regas, took a big hop. (Courtesy Rich Ormbrek.)

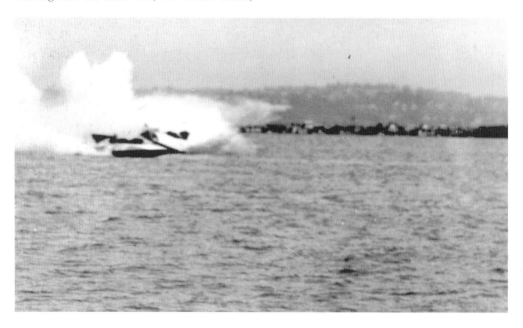

THE NOSE OF THE BOAT dug in, breaking off and pitching Regas into the water. The boat then turned sideways, directly in the path of the speeding *Harrah's Club*. (Courtesy Rich Ormbrek.)

1963–1968: MISS BARDAHL

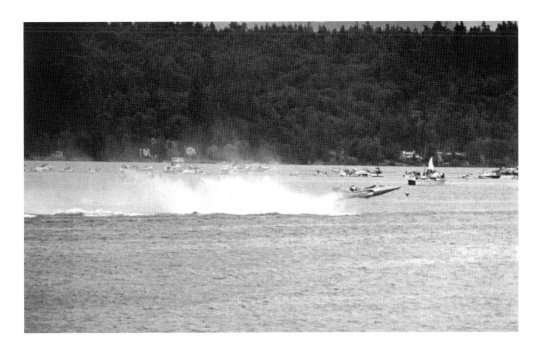

THE DEFENDING GOLD CUP CHAMPION, *Harrah's Club*, being driven by Chuck Hickling, was late for the start and trailing the field. It hit the stricken *Notre Dame* and launched into the air.

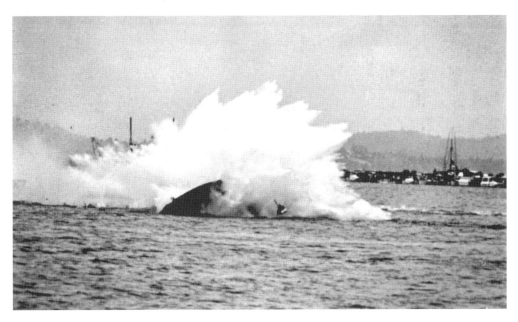

UPON LANDING, THE *Harrah's Club* rolled over, throwing Hickling into the water. Amazingly enough, neither driver was seriously injured. The *Notre Dame* was a total loss, but the *Harrah's Club* was rebuilt and raced again in 1968. (Courtesy Rich Ormbrek.)

BILL MUNCEY RETURNED TO THE winner's circle in Seattle when he won the 1968 world championship in George Simon's *Miss U.S.*

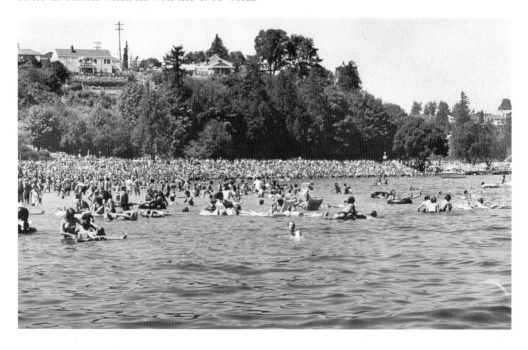

SEAFAIR CONTINUED TO BE A HUGELY POPULAR EVENT, with hundreds of thousands of fans attending the race each year. (Courtesy Seafair.)

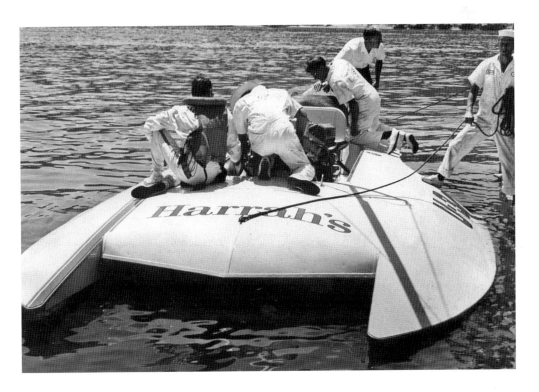

BILL HARRAH'S *HARRAH'S CLUB*, damaged in the 1967 Gold Cup, returned in 1968 with a new look. The boat sported a deeply forked nose. This design, called a "pickle fork," would soon dominate the sport.

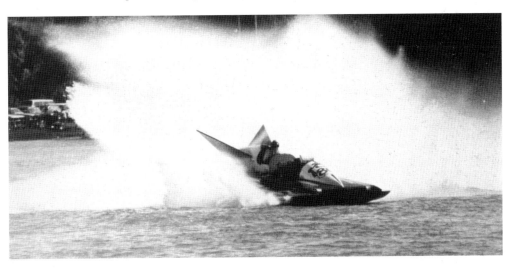

SMIRNOFF UNVEILED A NEW LOOK in 1968 as well. This unique boat had a "V" tail fin, a flat deck, and was also pickle forked. The boat's performance was unimpressive, but its rookie driver, Dean Chenoweth, caught everyone's eye and would soon be one of the sport's top drivers. (Courtesy Gale Enterprises.)

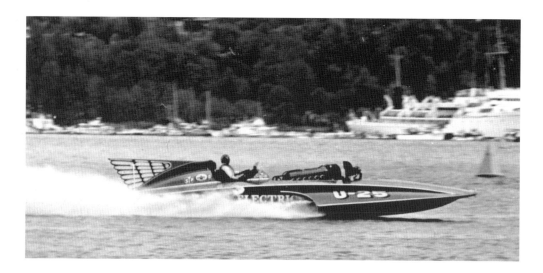

DAVE HEERENSPERGER OF SPOKANE owned the Miss Eagle Electric. Popular Warner Gardner drove the "Eagle" to three victories in 1968 and was in contention in the final heat of the Gold Cup in Detroit when the boat flipped going into the tight roostertail turn. Gardner was killed and the boat destroyed. (Photograph by E. K. Muller.)

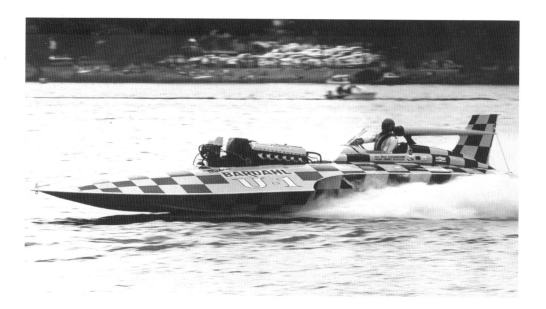

BILLY SCHUMACHER AND THE MISS BARDAHL continued their winning ways, capturing the Gold Cup and national championship. The Miss Bardahl sported a new paint scheme in 1968. Bardahl picked up an associate sponsorship from Autolite for 1968, and the team felt that a new distinctive paint scheme was needed. Longtime crewman David Smith came up with this checkerboard scheme and fans loved it. The boat was soon known as "The Checkerboard Comet."

5

1 9 6 9 – 1 9 7 5
B U D V S . P A K

After winning the Gold Cup and national championship five times in six years, Ole Bardahl retired from racing at the end of the 1968 season. Ole never publicly explained his decision, but the rising cost of racing and the negative media attention given to the fatal accidents had to be considerations.

In 1969, two new teams rose to the top of the field—Bernie Little's *Miss Budweiser* and Lee Schoenith's *Myr's Special*. The *Budweiser*, built by Ed Karelsen and driven by Bill Sterett, was an exact copy of the *Bardahl*. The *Myr's Special* was a new type of boat featuring a bow that was recessed behind the sponson tips to give the boat a distinctive fork shape. This new design was called a pickle fork. Dean Chenoweth drove the *Myr's*.

When the fleet arrived in Seattle for the Seafair race, *Myr's* had a 750 point lead in the national high point race but a dismal day saw the *Myr's* only score 225 points and give the race and the championship to *Bud*.

Bernie and the *Bud* repeated as national champions in 1970 and 1971. Bill Muncey returned to center stage in 1972, when he won all but one race in a new boat sponsored by Atlas Van Lines. The *Atlas*, a virtual copy of the *Myr's*, was owned by Lee Schoenith. With the *Atlas* win in 1972, hydroplane racing clearly entered a new era. From that date on, every Seafair winner, every national high point champion, and every Gold Cup winner was a pickle fork hydro!

There were more changes on the horizon. Dave Heerensperger, who owned the popular Pay N' Pak building supply stores, brought out a new Ron Jones–designed *Pay N' Pak* in 1973. The boat was remarkable for a number of reasons, but the most obvious were the horizontal rear stabilizer and deep outboard mounted skid fin. Less obvious, but equally as important, was the boat's honeycomb aluminum construction. Borrowing from the aircraft industry, Jones had created a boat that was strong, light, and several years ahead of the competition.

The new boat took top honors in its very first race in Miami, Florida. When the boats arrived in Seattle in August for the world championship race, the high points battle had boiled down to a two-boat duel between Mickey Remund in the new *Pay N' Pak* and Dean Chenoweth in the *Miss Budweiser*. For the first time in years, weather played a part in the contest, as race day dawned cold and rainy. Fog covered the course and visibility was only a few hundred yards. That did not deter Dean or Mickey, as they staged one of the closest, most dynamic races in the sport's history, with the "Pak" just edging out a win.

Many changes in 1974 happened on and off the course. Businessman Jim Clapp financed a serious effort to introduce turbine engines into the sport. Clapp, an heir to the Weyerhauser fortune, had been prompted into building the revolutionary boat after a late night conversation with a longtime friend, radio personality Pat O'Day. Clapp's revolutionary boat, designed and

built by Ron Jones, featured twin Lycoming T-53 motors, three vertical tail fins, and a horizontal stabilizer. Clapp did not put a commercial sponsor name on the boat, but elected to simply call it the *U-95* (95 being the dial position for Pat O-Day's popular KJR radio station). Unfortunately Jim died of cancer before the boat ever raced, but his widow, Pam, agreed to run the boat in his memory. The boat showed flashes of brilliance—qualifying fast, winning a heat, and setting a record—before sinking at the Seattle Gold Cup. The boat was retired after the Gold Cup, but observant fans could see the handwriting was on the wall—it would not be long before turbines would be back to stay.

Financial pressure prompted Seafair officials to move the race from its traditional location south of the floating bridge to a new location on the north end of Lake Washington at Sand Point Naval Air Station. The move allowed the festival to charge admission for the first time. The race was disappointing from a number of angles. Fans hated watching the race from the hot dusty military base and stayed home to watch on television. Seafair officials felt that gate revenues were surprisingly low. Competitors thought that the course was lumpy and exposed to the wind. But the racing was extraordinary! The *Bud* and *Pak* hooked up in a legendary duel that lasted all day long and saw George Henley in the *Pay N' Pak* beat Howie Benns in the *Budweiser*.

In 1975, the *Pak* won five out of 10 races, including the Gold Cup and Seafair, on its way to a third consecutive national championship.

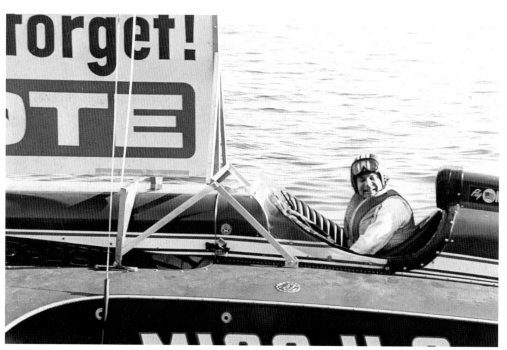

IN 1969, BILL MUNCEY ran for lieutenant governor of Washington. In an effort to get out the vote, Muncey placed a sign on the *Miss U.S.* that said, "Don't Forget to Vote," and drove alongside the I-90 bridge during morning rush hour. He lost the election. (Courtesy U.S. Navy.)

1969–1975: BUD VS. PAK

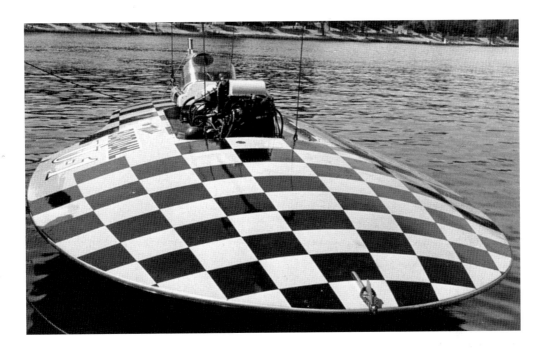

AT THE LAST MINUTE, the Bardahl team decided to take part in the 1969 Seafair Race. The yellow and black *Miss Bardahl* was brought out of retirement, and veteran driver Fred Alter was hired to drive. The *Bardahl* won its first two heats but didn't finish the final one. (Photograph by Audris Skuja.)

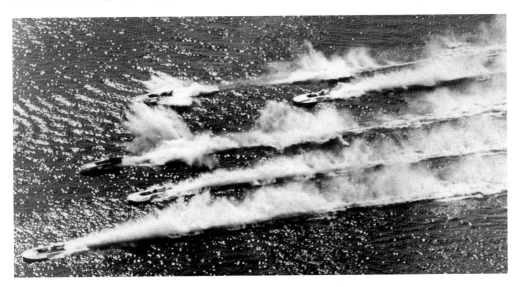

THE FINAL HEAT OF THE 1969 Seafair race got off to an exciting start when the *Parco's O-ring Miss*, driven by Norm Evans, cut across the course leaving a huge wake at the starting line. Note the big splash from the *Miss U.S.* and *Bardahl* as they barely escape crashing. (Courtesy Unlimited Racing Commission.)

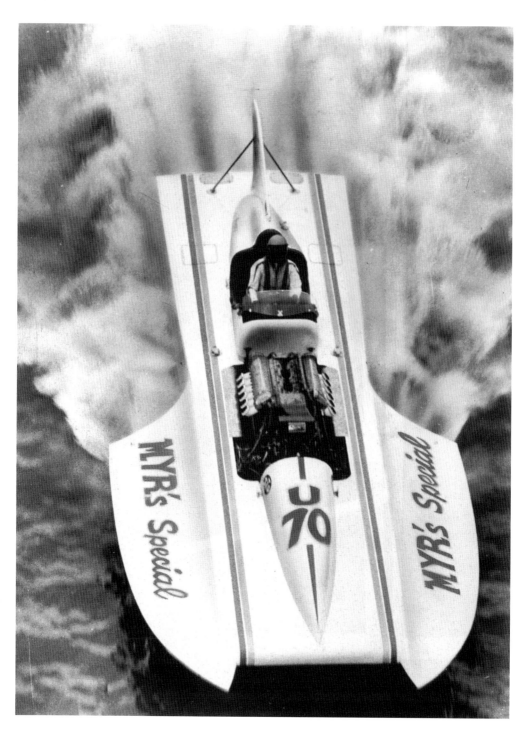

IN 1969, DEAN CHENOWETH DROVE Lee Schoenith's *Myr's Special*. It was one of the fastest boats on the circuit. (Courtesy Bill Osborne.)

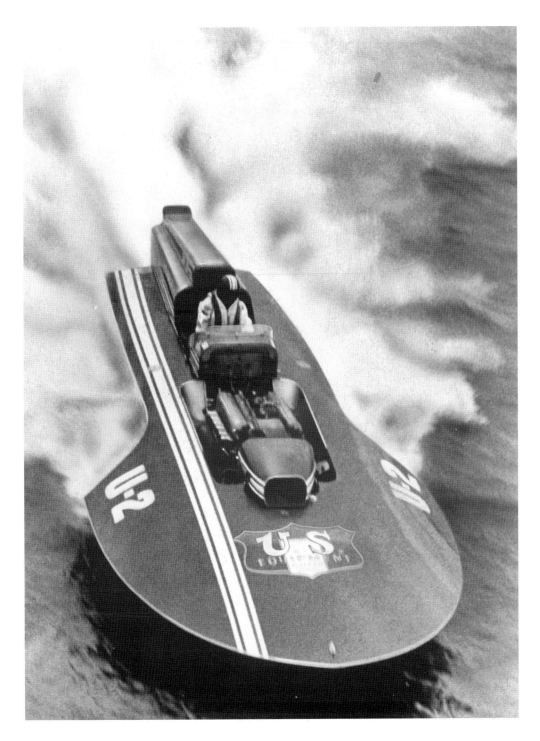

Bill Muncey followed up his 1968 world championship victory on Lake Washington by winning the 1969 world championship in Detroit. The team came into Seafair as one of the favorites. (Courtesy Bill Osborne.)

THE MISS BUDWEISER, owned by Bernie Little and driven by Bill Sterett, was an exact copy of the 1967 Miss Bardahl. The Budweiser was built in 1968 by Ed Karelsen from the same plans as the Bardahl. The tail fin and cockpit on the Bud were originally used by the Bardahl in 1967 but were surplused when Bardahl went to the checkered board paint scheme. (Photograph by Bill Osborne.)

BILL STERETT AND THE BUDWEISER had a perfect day at the 1969 Seafair trophy race, winning all three heats and the race. The Budweiser went on to win the 1969 Gold Cup in San Diego and the national championship.

1969–1975: BUD VS. PAK

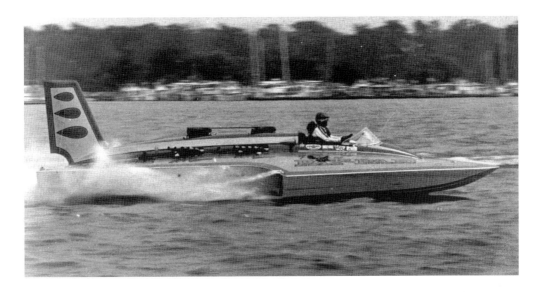

THE YEAR 1970 SAW SEVERAL NEW BOATS on the circuit. One of the more interesting was this twin automotive powered, rear engine *Pride of Pay N' Pak* built by Ron Jones for David Heerensperger. The boat was Ron's first unlimited since the ill-fated rear engine *Bardahl*. Driven by Tommy Fults and Ron Larsen, the boat was plagued by mechanical difficulties.

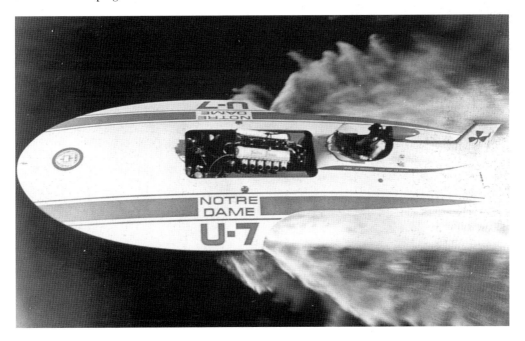

ANOTHER NEW BOAT IN 1970 was the *Notre Dame*. Built by Ed Karelsen, the boat was similar in design to the *Bardahl* and *Budweiser* but was reportedly lighter. Driven by Leif Borgensen, the boat was fast but inconsistent. (Courtesy Bruce McKim.)

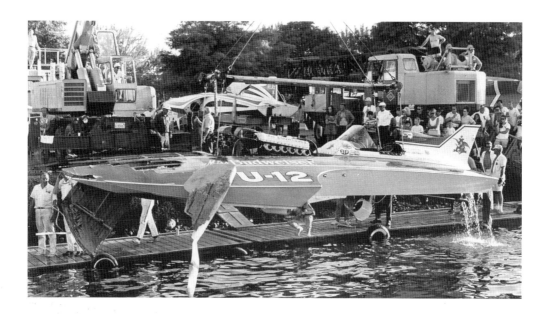

TWO WEEKS BEFORE SEAFAIR, the *Miss Budweiser* crashed at the race in Tri-Cities, Washington, and sank to the bottom of the Columbia River. The boat suffered major damage but driver Dean Chenoweth escaped serious injury. The crew, along with builder Ed Karelsen, worked around the clock to repair the boat in time for Seafair. (Photograph by Rich Ormbrek.)

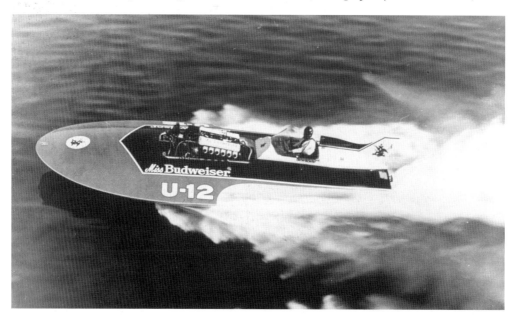

THE REPAIRED *BUDWEISER* won the race and the headline in the local paper read "From Columbia's Bottom to Seafair's Top!" The *Budweiser* went on to win the Gold Cup and national championship for a second year in a row. (Courtesy Bruce McKim.)

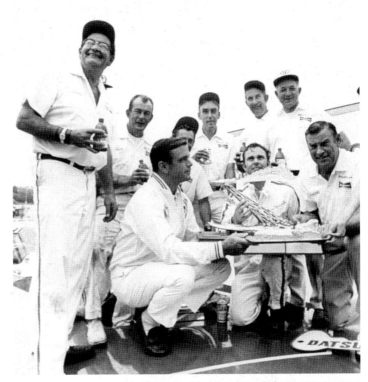

THE *MISS BUDWEISER* CREW, from left to right, is George Mckernan, Scotty Freeman, August Busch III (kneeling), Howie Lichtenwalter (kneeling behind August), Burns Smith, Dean Chenoweth (kneeling behind trophy), Tommy Frankhouser, Nelson Kenny, and Bernie Little (kneeling to the right of the trophy). (Photograph by Bill Osborne.)

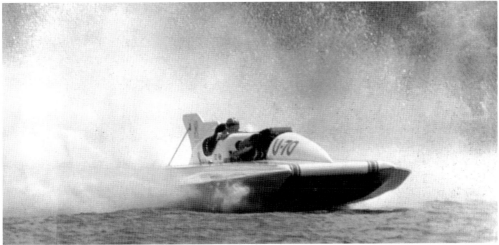

IN 1970, BILL MUNCEY MOVED from the Miss U.S. team to the Myr Sheet Metal team. Few people noted or even commented on the fact that the Myr was owned by Lee Schoentih and Gale Enterprises. Lee and the *Gale V* had edged Muncey to win the controversial 1955 Gold Cup. The Myr team won three of the first four races in 1970 and seemed to have a lock on the national championship, but a poor showing in the final three races of the year gave the lead to *Budweiser*. (Courtesy Bill Muncey collection.)

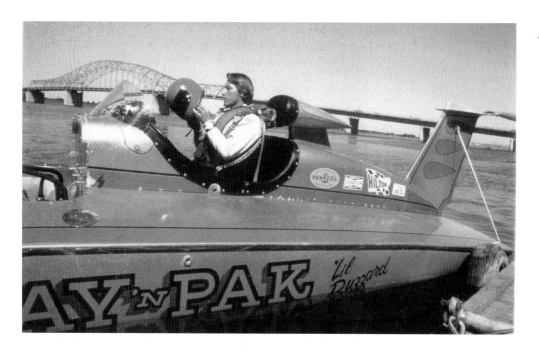

FORMER ROOKIE OF THE YEAR Tommy Fults was the young and popular driver of Pay N' Pak's 'Lil Buzzard during the second half of 1970. His dashing good looks made him a fan favorite.

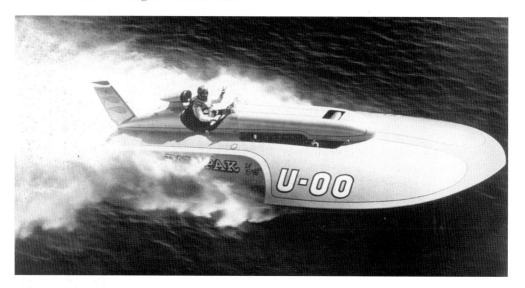

WHILE TAKING PART IN A LOW-SPEED run for a photograph shoot at the San Diego race, the *Buzzard* hit the wake of the *Notre Dame*. The *Buzzard* dug in a sponson, and a wall of water washed over the *Buzzard's* cockpit, breaking Tommy's neck and killing him. Tommy was an organ donor, and his death brought new life to two people in San Diego, who each received one of his kidneys. (Courtesy Unlimited Racing Commission.)

1969–1975: BUD VS. PAK

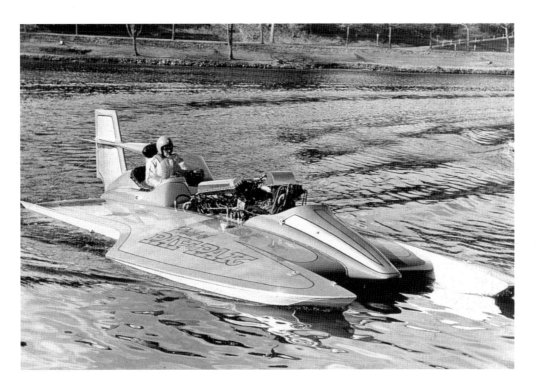

THE TWIN AUTOMOTIVE, REAR ENGINE *Pride of Pay N' Pak* was converted to a single forward mounted aircraft engine for the start of the 1971 season. The newly configured boat was fast, cornered well, and was a harbinger of things to come. The boat really hit its stride at Seafair, setting a qualifying record and winning not only the Seafair race but the next two races as well. (Photograph by Jack Brow.)

BILLY SCHUMACHER RETURNED to the winner's circle in the *Pay N' Pak*, but the smiles didn't last long. A dispute over safety issues caused Billy to leave the team in the middle of the 1972 season. This photograph shows Billy and his wife, Cindy, sitting on the back of the *Pay N' Pak*, while owner David Heerensperger perches on the tail fin behind them. (Photograph by Jack Brow.)

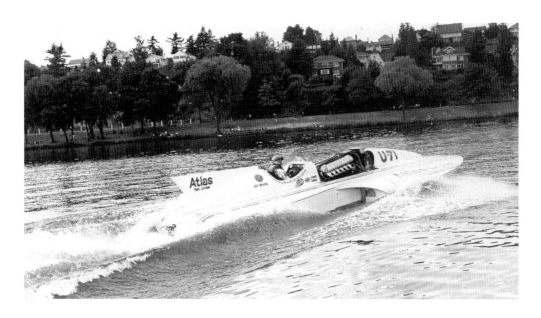

THE 1972 SEASON WAS TOTALLY DOMINATED by Bill Muncey and the *Atlas Van Lines*. They won all but one race, including the Gold Cup and national championship. (Courtesy Atlas Van Lines.)

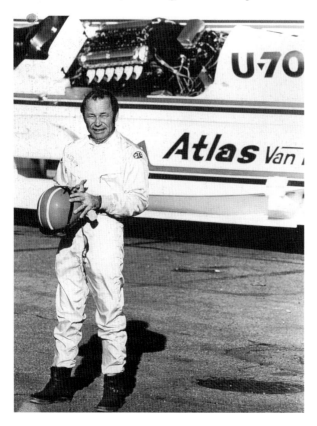

BILL'S VICTORY IN THE 1972 Gold Cup gave him five Gold Cup wins, tying him with the legendary Gar Wood, who dominated Gold Cup racing in the 1920s. (Courtesy Atlas Van Lines.)

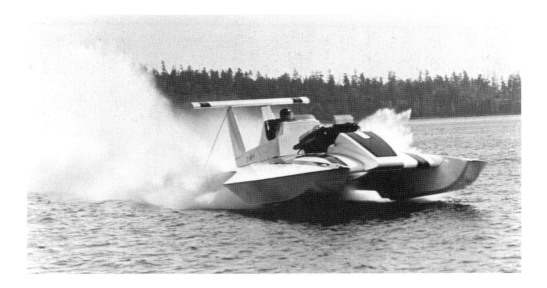

RON JONES BUILT A BRAND-NEW *Pay N' Pak* for Dave Heerensperger in 1973. The new boat was innovative for a number of reasons, the most notable of which was the horizontal stabilizer on the back of the boat. Less visible but equally important was the boat's lightweight, honeycomb aluminum construction. The boat was quickly dubbed the "Winged Wonder" by the media. (Courtesy Bill Osborne.)

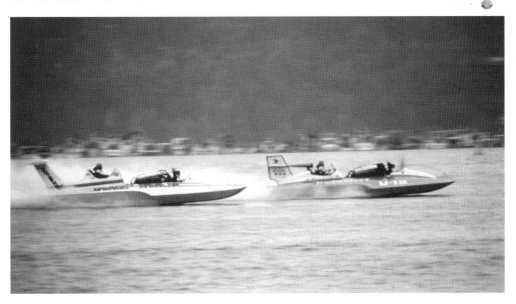

THE NEW *PAY N' PAK*, with Mickey Remund driving, was leading the Gold Cup when a broken propeller forced it out of the race. Two weeks later at Seafair, rain and fog cut visibility to almost zero, but the *Bud* and *Pak*, pictured here, staged a classic race that kept fans on their feet for all three heats. The *Pak* won, and went on to claim the National High Point Championship.

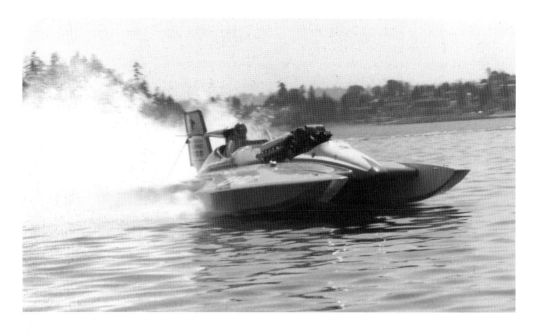

THE 1973 MISS BUDWEISER WAS actually the former 1970–1972 Pay N' Pak, but it found new life at the hands of the Bud crew and talented driver Dean Chenoweth.

AT THE END OF THE 1973 SEASON, Chenoweth decided to retire, leaving the sport with two national championships and two Gold Cups after only six years of competition. Budweiser owner Bernie Little is on the left and Dean Chenoweth is on the right.

THE 1974 SEASON GOT OFF to bloody start when Skipp Walther, brother of infamous Indy 500 driver Salt Walther, filled in for Jim McCormick in the *Red Man* at Miami.

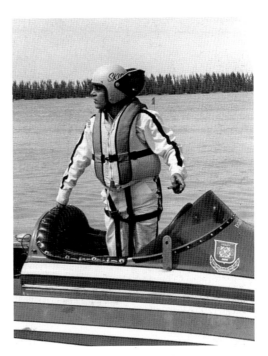

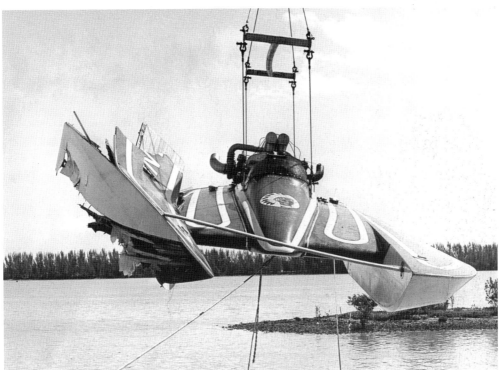

IN A PRERACE TEST RUN, the boat hit a manatee, lost its rudder, and spun violently. Skipp was thrown from the spinning boat, clipped by the boat's transom, and died instantly.

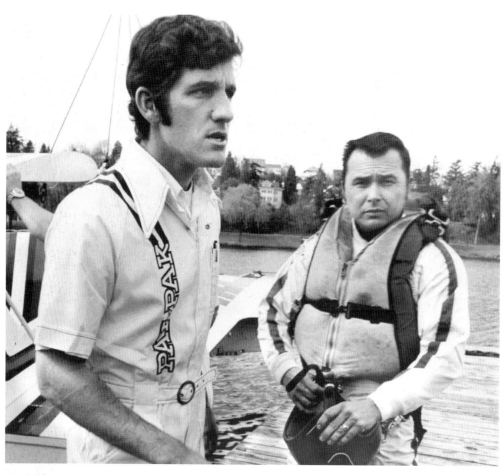

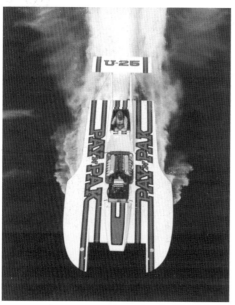

In 1974, George Henley was hired to drive the *Pay N' Pak*. This photograph shows George (right) with *Pay N' Pak* crew chief Jim Lucero at a preseason test on Lake Washington. (Courtesy Pay N' Pak.)

Henley and the *Pak* were an almost unbeatable combination. The team won seven races, as well as the Gold Cup and national championship in 1974. (Photograph by Bill Osborne.)

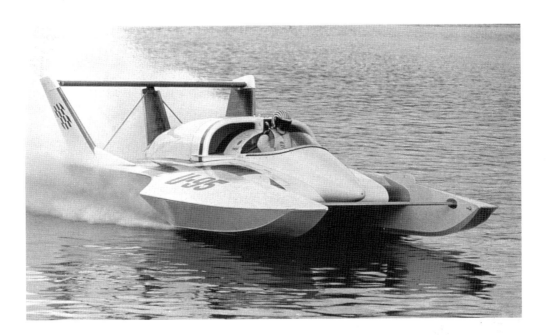

THE U-95, THE FIRST SERIOUS turbine contender, hit the water in 1974. The revolutionary boat was designed and built by Ron Jones. Owner Jim Clapp died before the boat ever saw competition, but his wife, Pam, ran it in the 1974 season out of respect for his wishes. (Photograph by Bob Carver.)

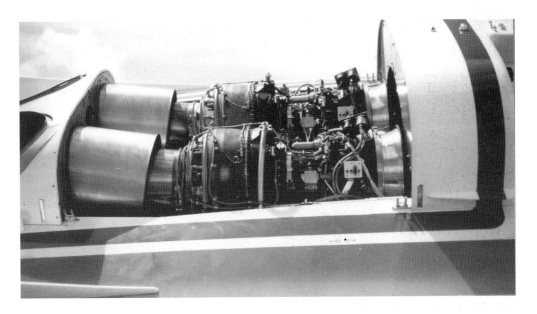

THE UNLIMITED RULES IN 1974 did not allow for a large enough turbine to power the boat so two motors were used. Twin T-53 Lycomings were coupled in to a single prop shaft with a unique T drive gearbox. (Photograph by Bill Osborne.)

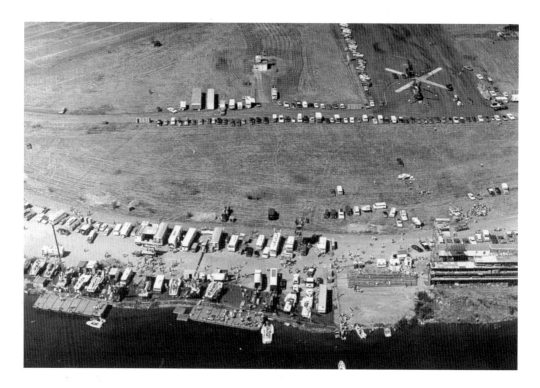

IN 1974, POLITICAL PRESSURES forced Seafair to move the Gold Cup race from its traditional Seattle location at Stan Sayres Pits to Sand Point Naval Air Station. The move seemed to disappoint just about everyone and the race was back at Stan Sayres in 1975. This aerial view of the Sand Point pit area shows how dry, hot, dusty, and shadeless it was. (Photograph by Stearns.)

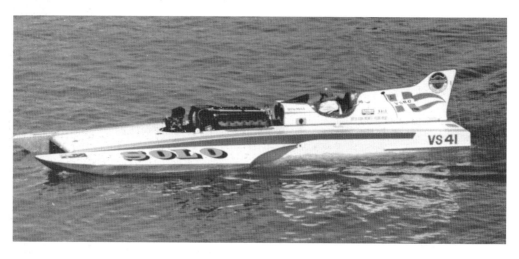

ONE OF THE FEW UPBEAT THINGS about the 1974 Gold Cup was that it was the first international competition in years. The *Solo*, owned by Stan Jones of Australia, came up for the race but failed to finish a heat.

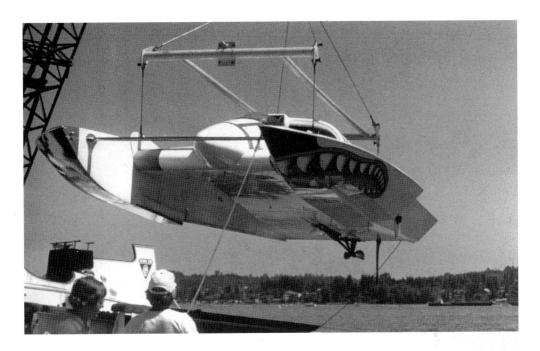

ASIDE FROM A THRILLING DUEL between the *Bud* and the *Pak*, the 1974 Sand Point Gold Cup is best remembered for two mishaps. During the first running of heat 1-C, the *U-95* blew a hot section on one of its motors and flying metal tore out a large portion of the bottom of the boat, causing it to sink. Seattle fans long remember the shark's teeth of the *U-95* bobbing out of the water as the boat slowly went down to the bottom of the lake. (Photograph by Jim Dunn.)

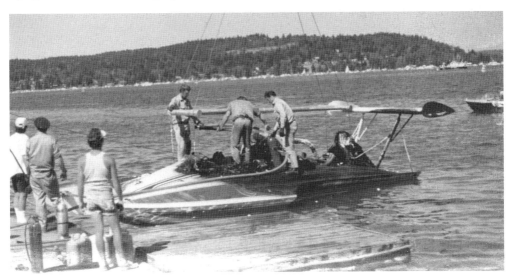

IN THE SECOND RUNNING OF HEAT 1-C, the *Miss U.S.* caught fire, and timid fire crews were unwilling to get close enough to put the fire out until the boat was badly damaged.

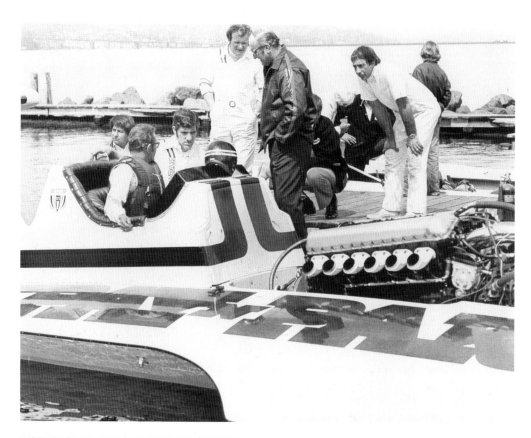

AT THE START OF THE 1975 season, Jim McCormick replaced George Henley in the cockpit of the *Pay N' Pak*. In this photograph, McCormick sits in the boat talking with Jim Lucero while Roger Bauer, Dave Heerensperger, and Bill Penland listen in.

MCCORMICK NEVER QUITE GOT the knack of driving the *Pay N' Pak*, and by mid season, George Henley was back in the seat. Henley won five of the last six races, including the Gold Cup, the Seafair trophy, and the national championship.

6

1976–1981
MUNCEY REPRISE

Lee Schoenith and Dave Heerensperger retired from racing at the end of the 1975 season. Fans wondered about the future of the sport without two of its biggest competitors.

Bill Muncey, who was well known for the calculated risks he was willing to take on the racecourse, now made a business move that shocked his competitors. He purchased the entire Pay N' Pak team. In the extraordinary deal, Muncey combined the rich Atlas sponsorship and the national championship Pay N' Pak team!

Not only did Muncey get the three-time national championship *Pay N' Pak* hull and its legendary crew chief Jim Lucero, but he also purchased an unfinished rear engine hull that was rumored to be the next step in the evolution of racing.

Muncey started the season with a victory in Miami and went on to win four more races on his way to the national championship. The *Miss U.S.*, owned by Detroiter George Simon, won the Gold Cup.

Lucero convinced Muncey to try the rear engine "cabover" boat in 1977. The new boat was painted blue and was quickly dubbed the "Blue Blaster" by fans. It was fast, stable, and won the first three races of the season on its way to six victories and a Gold Cup win. Only a disappointing showing at Madison kept Muncey from claiming the national championship. The "Blue Blaster" dominated the competition for the next two years, winning six out of seven races in 1978 and seven out of nine in 1979.

In 1979, Bernie Little hired Ron Jones to build a new Griffon-powered cabover that would be driven by Dean Chenoweth. The boat was finished in time for the Gold Cup but was too new to offer Muncey much competition. Bill won his third consecutive Gold Cup and his eighth overall. At the end of the season, Dean and the *Bud* tried for the world's water speed record on Lake Washington. The boat lost its rudder at over 217 miles per hour, blew over backwards, and was destroyed. Little ordered a new boat from Jones that was a virtual copy of the wrecked boat. The new boat, nicknamed the "Juggernaut," started out the 1980 season with an astounding five straight victories, including the Gold Cup. In Seattle, Chenoweth and the *Bud's* luck turned sour. Going into the south turn during a qualifying run, the boat lost its rudder and blew over into an inside barrel roll that broke off the left sponson. The *Atlas* took advantage of the Bud's accident, winning four of the last five races. A backup *Budweiser* was rushed to service and earned enough points to keep the *Bud* on top of the national high points race.

It was clear to everyone, including Bill Muncey, that the "Blue Blaster" was obsolete, but Muncey tried to wring one more season out of the valiant boat. After chasing the *Budweiser* for the entire 1981 season and only managing to win one race to the *Budweiser's* five, the fleet arrived in Acapulco, Mexico, for the Union of International Motorboating

World Championship.

The *Bud* qualified fastest and beat the *Atlas* twice in the preliminary heats. During the warm up for the final heat, Bill and Dean played a cat and mouse game, fighting for the inside lane, but in the final turn before the start, Bill swung the *Atlas* wide, leading everyone to believe that he was giving up on the inside lane. Then as the boats accelerated towards the line, Muncey cut across the backs of their roostertails and dove into an opening in lane one. He hit the line wide open and blasted through the first turn with the lead. Moving up the backstretch, he extended his lead, but just as he reached the entrance to the second turn, the nose of the boat lifted. The *Atlas* hung in the air for an impossibly long second and then somersaulted backwards. The boat hit nose first, throwing Muncey into the water. Chip Hanauer in the *Squire Shop* was unable to avoid the wrecked boat and drove over the upside-down *Atlas*. Milner Irvin spun the *Madison* hard to the left to avoid the scene. He too was thrown into the water. Confusion erupted in the pits. The fact that the locals all spoke Spanish and the racers only spoke English contributed to the confusion. Eventually Muncey was brought to the beach where medical personal waded through waist-deep water with his body on a stretcher. He was loaded into an ambulance and taken to the hospital. Stunned crews began the almost mechanical task of retrieving the damaged boats and loading them onto their trailers. Eventually word passed through the pits. Muncey, the greatest driver in the history of the sport, was dead.

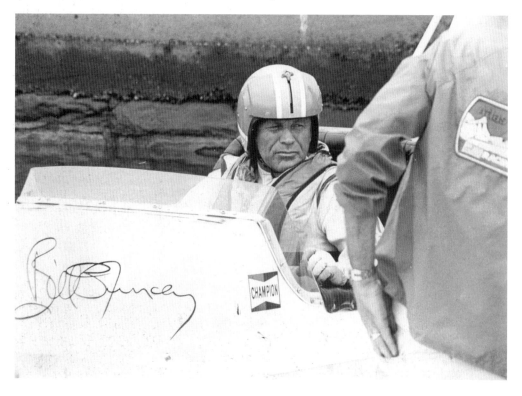

IN 1976, BILL TOOK A HUGE RISK when he bought the *Pay N' Pak* hull and renamed it *Atlas Van Lines*. It paid off in Bill's fifth national championship. (Courtesy Bill Muncey collection.)

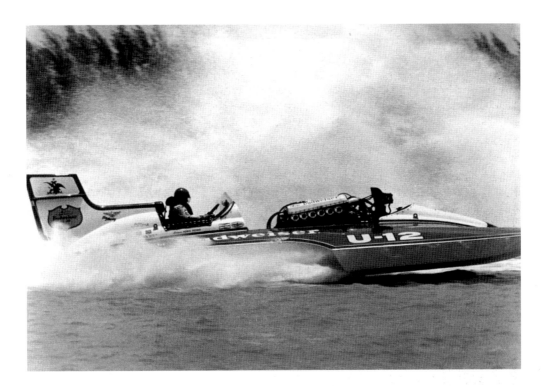

SOME OF THE STIFFEST COMPETITION FOR THE ATLAS came from a couple of beer boats. This photograph shows the *Miss Budweiser*, driven for half the season by Howie Benns and later by Mickey Remund. Remund won the Seafair race on Lake Washington.

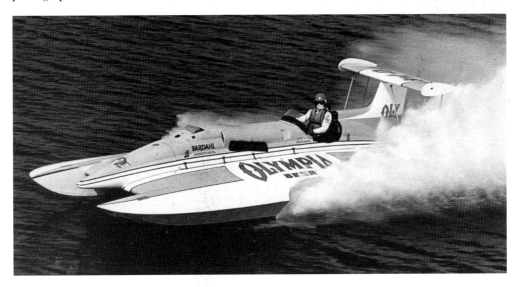

THE OLYMPIA BEER, driven by Bill Schumacher, was fast, but an accident in the Detroit Gold Cup kept it out of action for several races and hurt its chances in the national high points race.

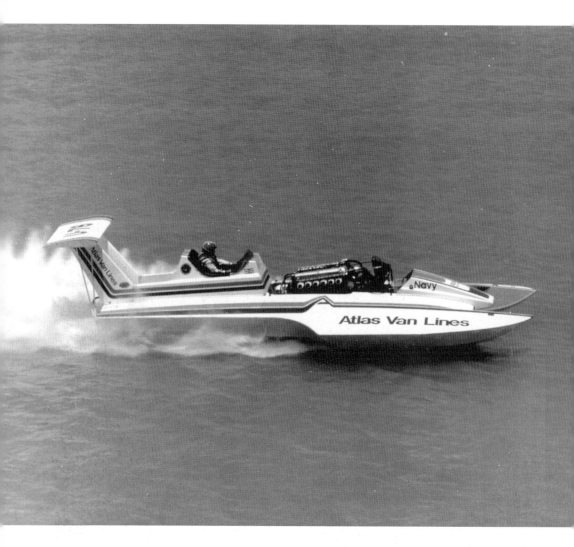

BILL MUNCEY MADE HIS DEBUT as a team owner with a victory at the first race of the season in Miami. Two races later, he was leading the final heat of the Gold Cup when an accident stopped the race. His crew discovered damage to the horizontal stabilizer and removed it for the rerun of the final. The boat was not as fast without its wing, and Tom D'Eath in the *Miss U.S.* was able to pull out a come-from-behind victory. After the disappointing Gold Cup loss, Muncey won four straight races and clinched the national championship. In honor of the nation's 1976 bicentennial celebration, Muncey used the number U-76 on the red, white, and blue *Atlas*.

HYDROPLANE RACING continued to be a hugely popular sport in the State of Washington, as this photograph of the *Olympia Beer* going by the parking lot at the Tri-Cities shows.

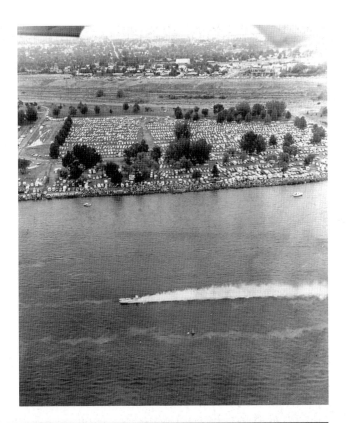

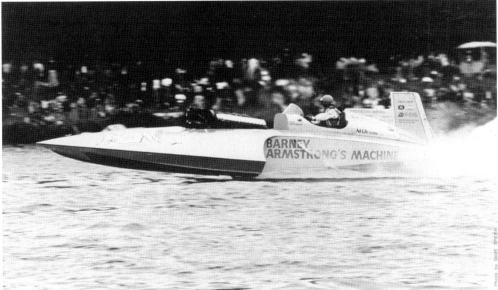

THE 1976 RACE IN TRI-CITIES saw a young rookie take to the course for the first time in an aging boat. Chip Hanauer failed to qualify in the *Barney Armstrong Machine* at Tri-Cities but got in to the race at Seafair and finished eighth. (Photograph by Dave Spear.)

WHEN MUNCEY BOUGHT THE PAY N' PAK equipment, he got an incomplete rear engine boat designed by longtime Pak crew chief Jim Lucero. Lucero convinced Muncey to finish the boat and use it in 1977. This photograph shows Muncey's first test run with the "Blue Blaster." (Photograph by Bob Carver.)

MUNCEY TEST DROVE TED JONES'S *Miss Thriftway Too* in 1957 and was unimpressed by the rear engine concept. When Bill's friend Ron Musson was killed behind the wheel of a rear engine boat, Muncey became an outspoken critic of rear engine boats. He often quipped that the only advantage of a rear engine boat was that the driver would be "first to the scene of an accident." The tremendous stability and cornering capabilities of the "Blue Blaster" quickly won Muncey over, as his smile in this photograph testifies. Muncey won six races, including his sixth Gold Cup in 1977, but just missed winning the National High Point Championship. (Photograph by Bill Osborne.)

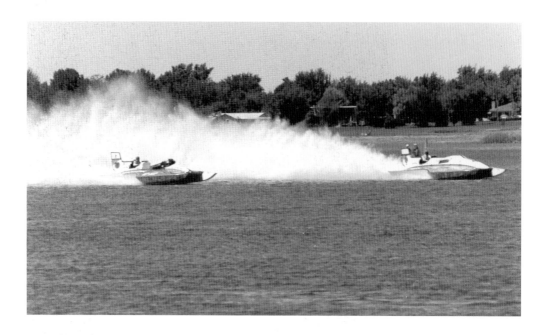

In 1977, BERNIE LITTLE RAN TWO boats for Anheuser Busch. The *Miss Budweiser* was driven by Mickey Remund and the *Natural* *Light* (formerly *Olympia Beer*) was driven by Tom Sheehy.

THE 1977 SEAFAIR RACE was darkened by the death of popular Jerry Bangs, driving the *Squire Shop*. Bangs, a successful lawyer with many years experience driving limited boats, hooked the *Squire* and was thrown out of the boat. He broke his neck when he hit the water. (Photograph by Bill Osborne.)

IN 1978, MUNCEY
SOLD the 1973 *Pay N'*
Pak hull to the City
of Madison, Indiana.
Jon Peddie and
Milner Irvin shared
the driving duties.

CIRCUS CIRCUS CASINOS ENTERED the sport of
unlimited racing at the end of the 1978 season
with rookie driver Steve Reynolds.

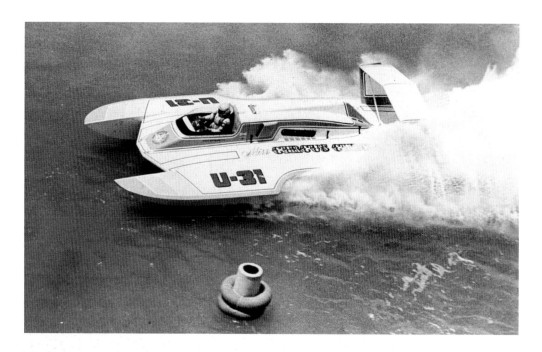

TWO NEW BOATS FROM THE DRAWING BOARD of Dave Knowlen hit the water in 1979. Knowlen teamed up with builder Norm Berg to produce the *Miss Circus Circus* for casino owner Bill Bennett and the *Squire Shop* for Bob Stiles, who owned a clothing chain called, not surprisingly, The Squire Shop. Steve Reynolds drove the *Circus,* and Chip Hanauer drove the *Squire Shop.* Each boat won one race in 1979.

THE BIGGEST DIFFERENCE BETWEEN the *Miss Circus Circus* and the *Squire Shop* is that the *Circus* was built out of honeycomb aluminum and the *Squire* was built with traditional wood construction.

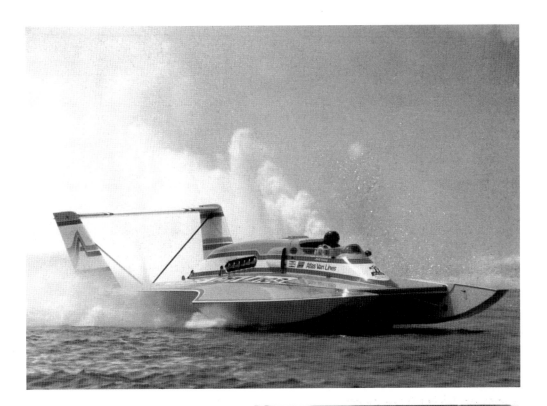

THE 1979 SEASON WAS AS CLOSE to perfect as Bill Muncey and the Atlas Van Lines team could hope for—they won seven out of nine races, including the Gold Cup, the Seafair race, and the national championship.

BILL'S GOLD CUP VICTORY IN MADISON on July 8, 1979, was his eighth Gold Cup victory in 25 years. In this photograph, the crew celebrates with Bill (pictured in the cockpit). From left to right are John Walter, Tim Ramsey, Jim Lucero, Ed Nelson, and Bill Muncey. (Courtesy Atlas Van Lines.)

HYDROPLANE RACING IN SEATTLE

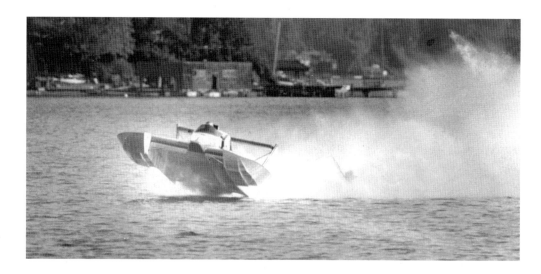

BERNIE LITTLE INTRODUCED A NEW rear engine Rolls Royce Griffon–powered hydroplane midway through the 1979 season. The boat was fast but didn't win any races. In an effort to salvage an accomplishment from the disappointing year, they decided to attempt the world water speed record. As the boat enters the timing run, it losses it rudder and the bow begins to lift. Ron Jones, (Photograph by Cary Tolman.)

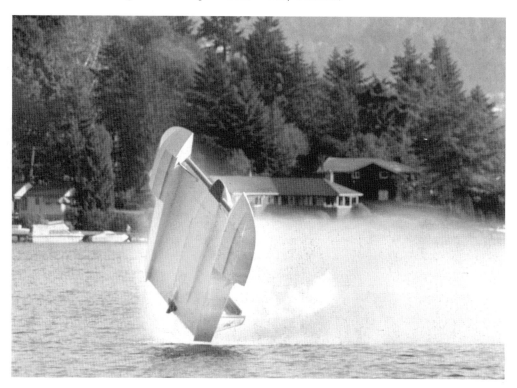

THE BOAT STANDS on its tail. (Photograph by Cary Tolman.)

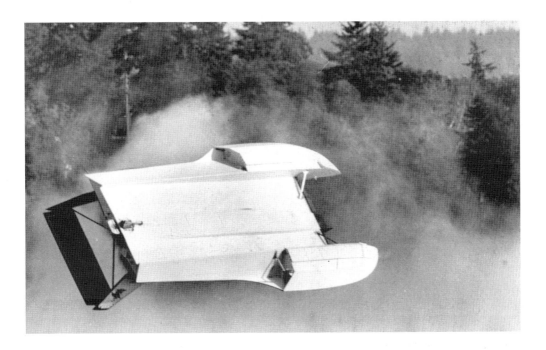

THE BOAT BLOWS OVER backwards. (Photograph by Cary Tolman.)

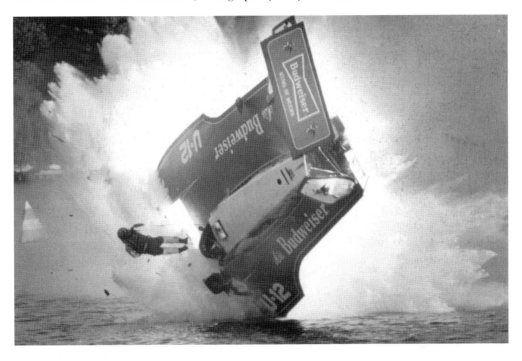

THE BOAT SLAMS DOWN nose first, throwing Dean Chenoweth into the water. Chenoweth was seriously injured but survived to race again the following year. (Photograph by Cary Tolman.)

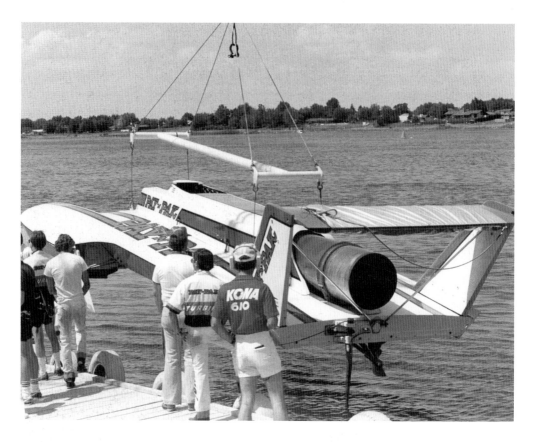

IN 1980, DAVE HEERENSPERGER launched a new Jim Lucero–designed, turbine-powered hydro.

Longtime *Pay N' Pak* crewman John Walters was hired to drive the ultralight boat.

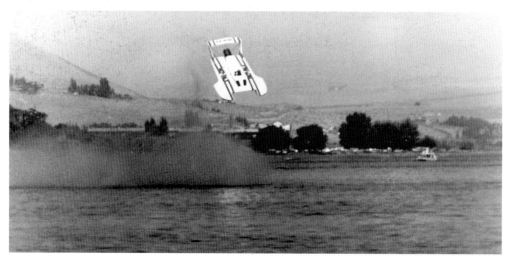

WHILE ATTEMPTING TO QUALIFY FOR ITS FIRST RACE, the *Pay N' Pak* became airborne.

(Photograph by Rich Ormbreck.)

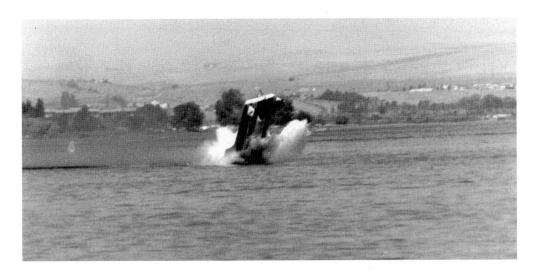

THE PAY N' PAK TURNED A COMPLETE back flip and landed nose first halfway through its second revolution. Walters was pitched in to the water and seriously injured.

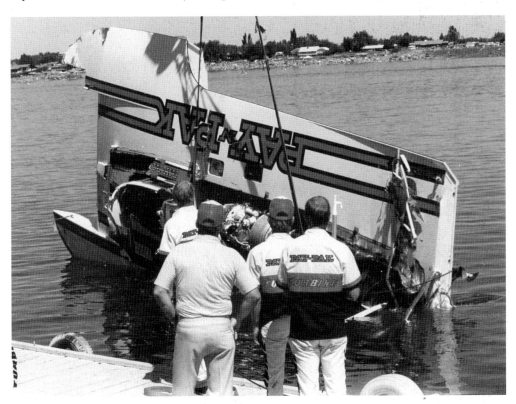

DAVE HEERENSPERGER (on the left with his back to the camera) watches as the wreck of the Pay N' Pak is lifted from the water. The boat was repaired for the 1981 season and, in 1982, became the first turbine-powered boat to win a race.

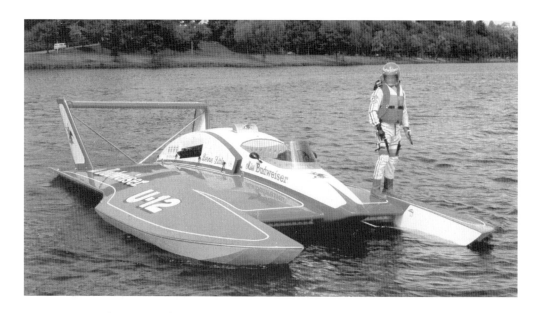

BERNIE LITTLE HAD A NEW GRIFFON *Budweiser* built to replace the boat damaged in the mile record attempt. From the moment it hit the water in 1980, it totally dominated the fleet, winning the first five races of the season, including the Gold Cup. The *Bud* lost its rudder while attempting to qualify in Seattle and flipped. *Atlas* won in Seattle over a replacement *Bud*, but *Budweiser's* high point lead was so big that it was still able to hold on and win the 1980 national championship. In 1981, the *Bud's* domination continued, winning six out of eight races, including the Gold Cup and national championship.

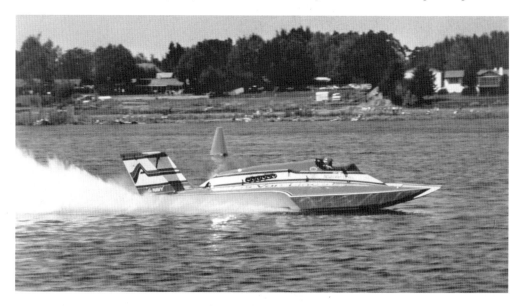

THE *ATLAS* STRUGGLED TO KEEP up with Chenoweth and the *Bud*. As the 1981 season drew to a close, Muncey and his crew began to make plans for a new boat in 1982.

BILL TOOK A LIKING TO YOUNG Chip Hanauer, seeing him as a talented driver who would make a logical protégé for Bill. (Courtesy Atlas Van Lines.)

THE LAST RACE OF THE 1981 season was the world championship in Acapulco, Mexico. This slightly out of focus photograph was taken on the beach before the final heat in Acapulco. It was the last photograph ever taken of Bill and Dean together.

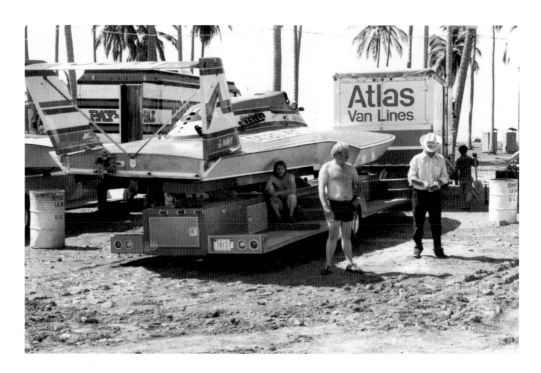

THIS PHOTOGRAPH SHOWS the *Atlas* just after it arrived at the racecourse in Acapulco.

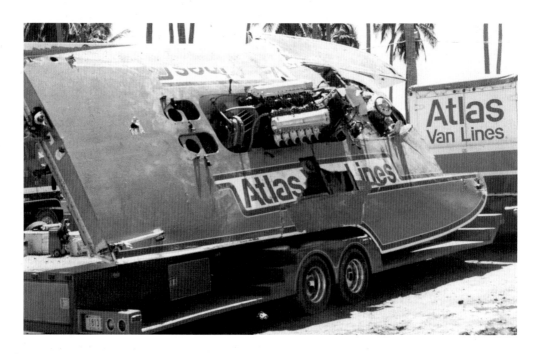

THE *ATLAS* IS PICTURED HERE after Muncey's fatal accident. Note how the steering wheel is bent forward, showing Muncey's tremendous strength as he fought to stay in the boat.

7

1982–1984
CHIP HANAUER

Bill Muncey's death rocked the sport to its core. Aside from being the sport's most successful driver, Bill had also become its most eloquent spokesman.

In early 1982, O. H. Frisbie, president of Atlas Van Lines and Bill's widow, Fran, decided that abandoning Atlas's commitment to boat racing would be an insult to Bill's memory. Together they made the decision to continue racing..

They kept the Atlas team intact and ordered a new Merlin-powered boat from Jim Lucero. They asked Chip Hanauer to drive. In many ways, Chip had been Bill's protégé.

The decision to race was made so late that it was a challenge to get the new boat finished before the season started. The new *Atlas* arrived at the first race in Miami without ever having been tested. The *Atlas* took second behind Chenoweth and the *Budweiser*. The next weekend, the Atlas came in fourth at Thunder in the Park in upstate New York. The race was won by Dave Heerensperger's *Pay N' Pak* turbine, the first victory ever by a turbine-powered hydroplane.

Two weeks later at the Gold Cup in Detroit, Chip and the *Atlas* qualified fastest and shocked the racing world by beating *Miss Budweiser* in a head-to-head race in the final heat.

When the fleet arrived in Washington State for the Tri-Cities race, it was clear that the season was developing into a shoot-out between Chenoweth in the *Bud* and Hanauer in the *Atlas*.

Atlas set a qualifying record of 138.429 miles per hour on Friday, just before the course closed. Early Saturday morning, Chenoweth went out to try to beat it. The weather was warm and bright, and Dean was the first driver out of the pits when the course opened at 9:30 a.m. His first lap was a respectable 126.050 miles per hour. He accelerated into lap two. As he crossed the starting line, a guest of wind caught the boat. It lifted the right sponson a foot or two, then the left. Dean rocked the boat to spill the air. The left sponson dipped then rose again. There was too much wind and the nose pitch high, the white bottom of the boat flashing in the morning sun as the *Bud* slammed down at over 175 miles per hour. A shower of spray hid the gruesome sight as Dean was crushed between the water and the boat. His death was instantaneous. When the spray settled, it was 9:38 on Saturday morning, and once more, the sport was facing the loss of a major figure.

Tommy D'Eath in the *Squire Shop* went on to win the race. One week later, the fleet was in Seattle. Again Chip Hanauer and the *Atlas* were the fastest qualifiers. Bernie Little hired veteran driver Ron Armstrong to drive the repaired *Budweiser*.

The race was expected to be a battle between *Atlas*, *Bud*, *Pay N' Pak*, and *Executone*, all fighting for the top spot. At the start of the first heat, *Bud* and *Atlas* broke across the line first. In lane six, the *Executone* lost its steering, took a hop, and veered left. The *Pay N' Pak*,

making a late start, drove over the top of the out of control *Executone*, flipping and throwing driver John Walters into the water. Concerned rescue workers swung into action. Even though Walter's injuries were serious, drivers and crew considered themselves lucky that no one was killed. Hanauer went on to win the race and the national championship. Hanauer and *Atlas* continued to dominate in 1983, winning both the Gold Cup and national championship for a second straight year.

In 1984, the team of Muncey, Lucero, and Hanauer fielded a new turbine-powered *Atlas Van Lines*.

Aside from the turbine engine, the 1984 *Atlas* also featured a crash cockpit with seat belts that was designed to keep a driver in the boat during an accident. The new boat struggled with a number of mechanical problems early in the season, but won two races, including the 1984 Gold Cup to give Chip Hanauer and the *Atlas* three consecutive Gold Cups.

The Seafair race and the national championship were both won by the Griffon-powered *Miss Budweiser*.

Nineteen hundred eighty-four was a season of endings and beginnings. Atlas left the sport. Never again would a piston-powered unlimited win either the Seafair or national championships. The new breed of faster, quieter turbines proved to dominate the sport of unlimited racing. The new crash cockpits would make the sport safer. Chip Hanauer was just beginning his winning ways with great things still to come. The old round nosed, piston-powered boats were forgotten for awhile, but eventually they found their way into the Hydroplane and Raceboat Museum where they have been lovingly restored and sent back on to the water to remind Seattleites what the glory days of racing were like.

AFTER THE DEVASTATING LOSS of her husband, Bill, Fran Muncey made the difficult decision to keep the Atlas team together and continue racing. (Courtesy Bill Muncey collection.)

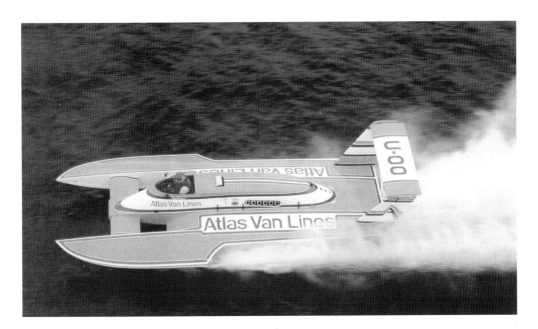

A NEW BOAT WAS ORDERED from Jim Lucero, with a hull that was very similar to the original "Blue Blaster." The pickle forks were deepened considerably, and a canard wing was set forward of the cockpit.

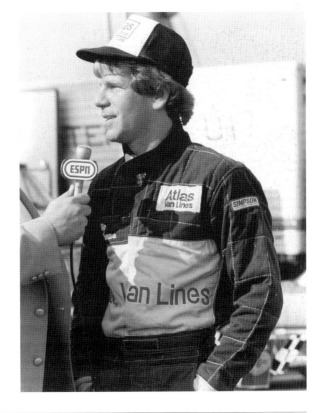

THERE NEVER WAS ANY DOUBT WHO BILL would have wanted to succeed him as the driver of the *Atlas*. Chip Hanauer was the only choice, and he was also the only driver that Fran and Atlas CEO O. H. Frisbie ever asked to drive the new boat. Chip had his hands full with the high-flying *Atlas* for his first few races, but it all came together for him when he beat the *Budweiser* in the Gold Cup in Detroit. (Courtesy Atlas Van Lines.)

DEAN CHENOWETH AND BERNIE LITTLE were not used to losing, and they arrived in Tri-Cities prepared to show the new Atlas team that the *Bud* was still the fastest boat on the circuit. After the *Atlas* set a qualifying record on Friday, Dean and the *Bud* were first on the water Saturday morning to try to break the record.

IT WAS NOT TO BE. The *Bud* flipped and Dean was killed. When the damaged *Budweiser* was loaded back on the trailer, crewmembers were stunned with how relatively undamaged the cockpit was. It was obvious to everyone looking at the wreckage that if Dean had only been able to stay in the boat, he would have survived. Throughout the sport, designers and builders began to wrestle in earnest with the notion of an enclosed cockpit with seat belts.

Shortly after Dean Chenoweth's fatal accident, Chuck Hickling sent his *Tempus*, with Jack Schafer Jr. driving, out onto the course carrying an American flag as a tribute to Dean.

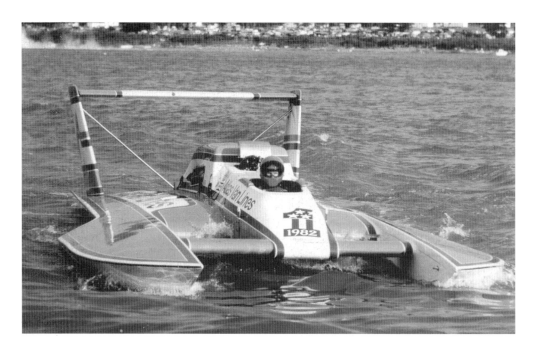

THE ATLAS WON THE 1982 NATIONAL championship, and in the offseason, the crew built a new "crash" cockpit on the boat that was stronger and featured a seat belt.

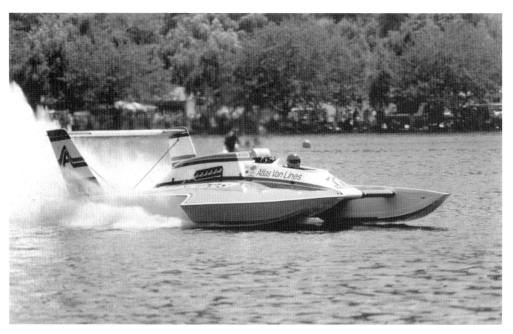

THE ATLAS CONTINUED ITS WINNING WAYS, capturing both the 1983 Gold Cup and national championship. Luckily neither the crash cockpit nor the seat belts were needed that season.

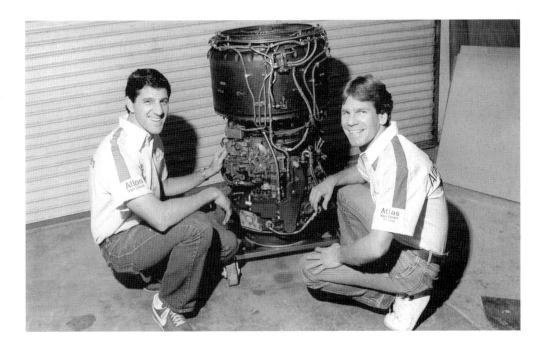

By the end of 1983, the mighty Allison, Merlin, and Griffon aircraft motors that had powered the unlimiteds for so long were just about used up. Atlas team manager Jim Lucero had been a longtime advocate of the turbine engine. He convinced Fran, O. H. Frisbie, and Chip that Atlas should try running a turbine. (Courtesy Atlas Van Lines.)

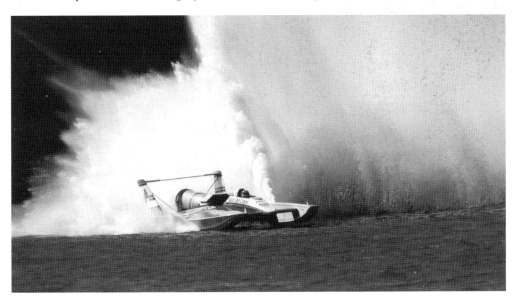

The new Atlas was completed late and missed the first two races of the 1984 season, but it proved to be fast and formidable, setting records and giving Chip and Atlas their third straight Gold Cup victory.

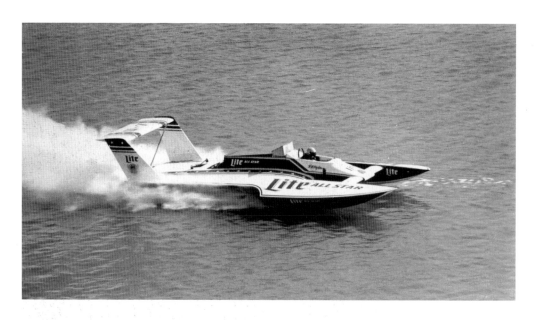

ATLAS WASN'T THE ONLY TEAM experimenting with a turbine in 1984. The *Lite All Star* was also running a new Jim Lucero turbine-powered hull. (Courtesy Miller Brewing.)

VETERAN DRIVER TOMMY D'EATH drove the *Lite All Star*. The boat fell victim to a series of mechanical problems. By 1985, Miller would switch their sponsorship to the Muncey team and Budweiser would buy the hull. (Courtesy Miller Brewing.)

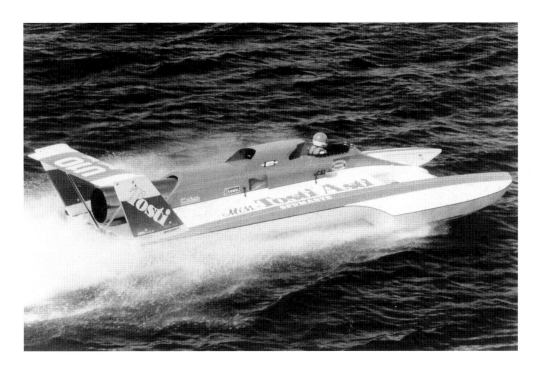

ANOTHER TURBINE TEAM was the Tosti Asti. This former *Pay N' Pak* hull was owned by Steve Woomer and driven by Steve Reynolds.

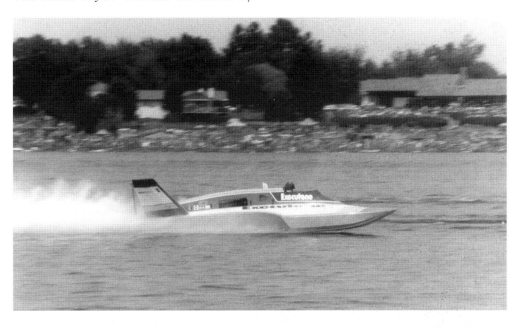

BILL WURSTER BROUGHT OUT a new Jim Lucero–designed *Executone* that was powered by a Rolls Royce Merlin. It was one of the last boats built specifically with a Merlin power plant in mind.

JERRY SCHOENITH, YOUNGER BROTHER of Lee Schoenith, ran the Allison-powered *Miss Renault*. This all-wood boat was built by Jon Staduacher, the son of Les Staduacher. (Courtesy Renault.)

BERNIE LITTLE, THE DEAN OF UNLIMITED HYDROPLANE OWNERS, ran the mighty Griffon Budweiser for one final season. The Bud took advantage of the teething difficulties that the turbine teams were experiencing with their new power plants and captured the 1984 national championship. It was to be the last national championship captured by a piston-powered boat in the history of unlimited racing.

HYDROPLANE RACING IN SEATTLE

THE GOLD CUP IS A PEWTER MUG that has been plated with gold. Built by Tiffany's in 1903, the trophy is beautiful but hardly seems worth the millions of dollars and many lives spent in its pursuit. But for the brave few that feel its lure, nothing can compare with the electric moment of supreme accomplishment that comes in winning it just once.

1982–1984: CHIP HANAUER

GOLD CUP WINNERS (1946–1984)

Year	Boat	Owner	Driver	Location
1946	*Tempo VI*	Guy Lombardo	Guy Lombardo	Detroit, MI
1947	*Miss Pepsi V*	Walt and Roy Dossin	Danny Foster	New York, NY
1948	*Miss Great Lakes*	A. F. Fallon	Danny Foster	Detroit, MI
1949	*My Sweetie*	Horace Dodge Jr.	Bill Cantrell	Detroit, MI
1950	*Slo Mo Shun IV*	Stanley Sayres	Ted Jones	Detroit, MI
1951	*Slo Mo Shun V*	Stanley Sayres	Lou Fageol	Seattle, WA
1952	*Slo Mo Shun IV*	Stanley Sayres	Stanley Dollar	Seattle, WA
1953	*Slo Mo Shun IV*	Stanley Sayres	L. Fageol/J. Taggart	Seattle, WA
1954	*Slo Mo Shun V*	Stanley Sayres	Lou Fageol	Seattle, WA
1955	*Gale V*	Joe Schoenith	Lee Schoenith	Seattle, WA
1956	*Miss Thriftway*	Willard Rhodes	Bill Muncey	Detroit, MI
1957	*Miss Thriftway*	Willard Rhodes	Bill Muncey	Seattle, WA
1958	*Hawaii Kai III*	Edgar Kaiser	Jack Regas	Seattle, WA
1959	*Maverick*	Bill Waggoner	Bill Stead	Seattle, WA
1960	Race Canceled			
1961	*Miss Century 21*	Willard Rhodes	Bill Muncey	Reno, NV
1962	*Miss Century 21*	Willard Rhodes	Bill Muncey	Seattle, WA
1963	*Miss Bardahl*	Ole Bardahl	Ron Musson	Detroit, MI
1964	*Miss Bardahl*	Ole Bardahl	Ron Musson	Detroit, MI
1965	*Miss Bardahl*	Ole Bardahl	Ron Musson	Seattle, WA
1966	*Tahoe Miss*	Bill Harrah	Mira Slovak	Detroit, MI
1967	*Miss Bardahl*	Ole Bardahl	Bill Schumacher	Seattle, WA
1968	*Miss Bardahl*	Ole Bardahl	Bill Schumacher	Detroit, MI
1969	*Miss Budweiser*	B. Little/T. Friedkin	Bill Sterett	San Diego, CA
1970	*Miss Budweiser*	B. Little/T. Friedkin	Dean Chenoweth	San Diego, CA
1971	*Miss Madison*	City of Madison	Jim McCormick	Madison, IN
1972	*Atlas Van Lines*	Joe Schoenith	Bill Muncey	Detroit, MI
1973	*Miss Budweiser*	Bernie Little	Dean Chenoweth	Tri-Cities, WA
1974	*Pay N Pak*	Dave Heerensperger	George Henley	Seattle, WA
1975	*Pay N Pak*	Dave Heerensperger	George Henley	Tri-Cities, WA
1976	*Miss U.S.*	George Simon	Tom D'Eath	Detroit, MI
1977	*Atlas Van Lines*	Muncey Enterprises	Bill Muncey	Detroit, MI
1978	*Atlas Van Lines*	Muncey Enterprises	Bill Muncey	Owensboro, KY
1979	*Atlas Van Lines*	Muncey Enterprises	Bill Muncey	Madison, IN
1980	*Miss Budweiser*	Bernie Little	Dean Chenoweth	Madison, IN
1981	*Miss Budweiser*	Bernie Little	Dean Chenoweth	Seattle, WA
1982	*Atlas Van Lines*	Muncey Enterprises	Chip Hanauer	Detroit, MI
1983	*Atlas Van Lines*	Muncey Enterprises	Chip Hanauer	Evansville, IN
1984	*Atlas Van Lines*	Muncey Enterprises	Chip Hanauer	Tri-Cities, WA

NATIONAL CHAMPIONS (1946–1984)

Year	Boat	Owner	Driver
1946	*Tempo VI*	Guy Lombardo	Guy Lombardo
1947	*Miss Pepsi V*	Walt and Roy Dossin	Danny Foster
1948	*Such Crust*	Jack Schaefer	Dan Arena
1949	*My Sweetie*	Horace Dodge Jr.	Bill Cantrell
1950*	*My Sweetie*	Horace Dodge Jr.	Bill Cantrell
1951	*Miss Pepsi*	Walt and Roy Dossin	Chuck Thompson
1952	*Miss Pepsi*	Walt and Roy Dossin	Chuck Thompson
1953	*Gale II*	Joe Schoenith	Lee Schoenith
1954	*Gale V*	Joe Schoenith	Lee Schoenith
1955	*Gale V*	Joe Schoenith	Lee Schoenith
1956	*Shanty I*	Bill Waggoner	Russ Schleeh
1957	*Hawaii Kai III*	Edgar Kaiser	Jack Regas
1958	*Miss Bardahl*	Ole Bardahl	Mira Slovak
1959	*Maverick*	Bill Waggoner	Bill Stead
1960	*Miss Thriftway*	Willard Rhodes	Bill Muncey
1961	*Miss Century 21*	Willard Rhodes	Bill Muncey
1962	*Miss Century 21*	Willard Rhodes	Bill Muncey
1963*	*Miss Bardahl*	Ole Bardahl	Ron Musson
1964	*Miss Bardahl*	Ole Bardahl	Ron Musson
1965	*Miss Bardahl*	Ole Bardahl	Ron Musson
1966	*Tahoe Miss*	Bill Harrah	Mira Slovak
1967	*Miss Bardahl*	Ole Bardahl	Bill Schumacher
1968	*Miss Bardahl*	Ole Bardahl	Bill Schumacher
1969	*Miss Budweiser*	B. Little/T. Friedkin	Bill Sterett
1970	*Miss Budweiser*	B. Little/T. Friedkin	Dean Chenoweth
1971	*Miss Budweiser*	B. Little/T. Friedkin	Dean Chenoweth
1972	*Atlas Van Lines*	Joe Schoenith	Bill Muncey
1973	*Pay N Pak*	Dave Heerensperger	Mickey Remund
1974	*Pay N Pak*	Dave Heerensperger	George Henley
1975*	*Pay N Pak*	Dave Heerensperger	George Henley
1976	*Atlas Van Lines*	Muncey Enterprises	Bill Muncey
1977	*Miss Budweiser*	Bernie Little	Mickey Remund
1978	*Atlas Van Lines*	Muncey Enterprises	Bill Muncey
1979	*Atlas Van Lines*	Muncey Enterprises	Bill Muncey
1980	*Miss Budweiser*	Bernie Little	Dean Chenoweth
1981	*Miss Budweiser*	Bernie Little	Dean Chenoweth
1982	*Atlas Van Lines*	Muncey Enterprises	Chip Hanauer
1983	*Atlas Van Lines*	Muncey Enterprises	Chip Hanauer
1984	*Miss Budweiser*	Bernie Little	Jim Kropfeld

*Three different times, the champion driver was not the driver of the champion boat. In 1950, Danny Foster was the champion driver. In 1963, it was Bill Cantrell and, in 1975, it was Billy Schumacher.

SEATTLE WINNERS (1951–1984)

Year	Boat	Owner	Driver	Race
1951	Slo Mo Shun V	Stanley Sayres	Lou Fageol	Gold Cup
1951	Slo Mo Shun V	Stanley Sayres	Ted Jones	Seafair Trophy
1952	Slo Mo Shun IV	Stanley Sayres	Stanley Dollar	Gold Cup
1953	Slo Mo Shun IV	Stanley Sayres	L. Fageol/J. Taggart	Gold Cup
1954	Slo Mo Shun	Stanley Sayres	Lou Fageol	Gold Cup
1955	Gale V	Joe Schoenith	Lee Schoenith	Gold Cup
1956	Shanty I	Bill Waggoner	Russ Schleeh	Seafair Trophy
1957	Miss Thriftway	Willard Rhodes	Bill Muncey	Gold Cup
1958	Hawaii Kai III	Edgar Kaiser	Jack Regas	Gold Cup
1959	Maverick	Bill Waggoner	Bill Stead	Gold Cup
1960	Miss Thriftway	Willard Rhodes	Bill Muncey	Seafair Trophy
1961	Miss Bardahl	Ole Bardahl	Ron Musson	World's Champion
1961	Miss Madison	City of Madison, IN	Marion Cooper	Seattle Trophy
1961	Fascination	Bob Gilliam	Bob Gilliam	Seafair Queens Trophy
1962	Miss Century 21	Willard Rhodes	Bill Muncey	Gold Cup
1962	Fascination	Bob Gilliam	Bob Larsen	Space Needle Handicap
1963	Tahoe Miss	Bill Harrah	Chuck Thompson	Seafair Trophy
1964	Miss Bardahl	Ole Bardahl	Ron Musson	Seafair Trophy
1965	Miss Bardahl	Ole Bardahl	Ron Musson	Gold Cup
1966	My Gypsy	Jim Ranger	Jim Ranger	Seafair Trophy
1967	Miss Bardahl	Ole Bardahl	Bill Schumacher	Gold Cup
1967	Chrysler Crew	Bill Sterett	Mira Slovak	Seattle Seafair
1968	Miss U.S.	George Simon	Bill Muncey	World's Champion
1969	Miss Budweiser	B. Little/T. Friedkin	Bill Sterett	Seafair Trophy
1970	Miss Budweiser	B. Little/T. Friedkin	Dean Chenoweth	Seafair Trophy
1971	Pay N Pak	Dave Heerensperger	Bill Schumacher	Seafair Trophy
1972	Atlas Van Lines	Joe Schoenith	Bill Muncey	Seafair Trophy
1973	Pay N Pak	Dave Heerensperger	Mickey Remund	World's Champion
1974	Pay N Pak	Dave Heerensperger	George Henley	Gold Cup
1975	Pay N Pak	Dave Heerensperger	George Henley	Seafair Trophy
1976	Miss Budweiser	Bernie Little	Mickey Remund	Seafair Trophy
1977	Atlas Van Lines	Muncey Enterprises	Bill Muncey	Seafair Trophy
1978	Atlas Van Lines	Muncey Enterprises	Bill Muncey	Seafair Trophy
1979	Atlas Van Lines	Muncey Enterprises	Bill Muncey	Seafair Trophy
1980	Atlas Van Lines	Muncey Enterprises	Bill Muncey	World's Champion
1981	Miss Budweiser	Bernie Little	Dean Chenoweth	Gold Cup
1981	Captran Resorts	Keight Trowbridge	Steve Reynolds	Seafair Trophy
1982	Atlas Van Lines	Muncey Enterprises	Chip Hanauer	Emerald Cup
1983	Miss Budweiser	Bernie Little	Jim Kropfeld	Emerald Cup
1984	Miss Budweiser	Bernie Little	Jim Kropfeld	Freedom Cup

Across America, People are Discovering Something Wonderful. Their Heritage.

Arcadia Publishing is the leading local history publisher in the United States. With more than 3,000 titles in print and hundreds of new titles released every year, Arcadia has extensive specialized experience chronicling the history of communities and celebrating America's hidden stories, bringing to life the people, places, and events from the past. To discover the history of other communities across the nation, please visit:

www.arcadiapublishing.com

Customized search tools allow you to find regional history books about the town where you grew up, the cities where your friends and family live, the town where your parents met, or even that retirement spot you've been dreaming about.